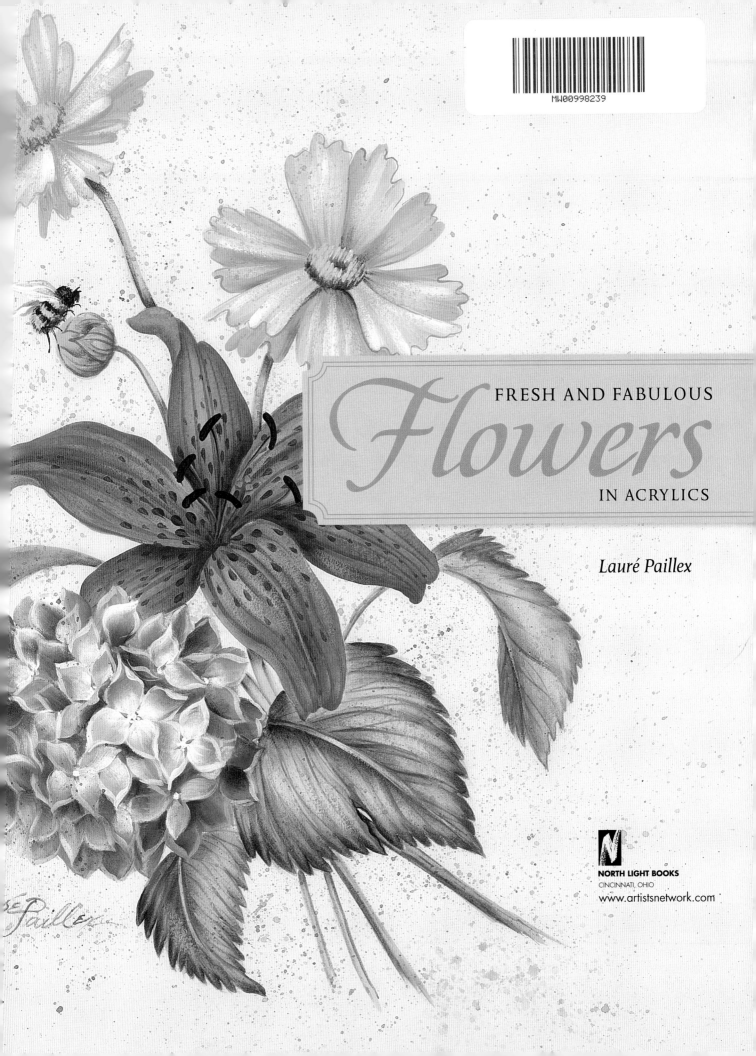

FRESH AND FABULOUS

Flowers

IN ACRYLICS

Lauré Paillex

NORTH LIGHT BOOKS
CINCINNATI, OHIO
www.artistsnetwork.com

Other fine North Light Books are available from your local bookstore, art supply store or direct from the publisher.

12 11 10 09 08 5 4 3 2 1

Distributed in Canada by Fraser Direct
100 Armstrong Avenue
Georgetown, ON, Canada L7G 5S4
Tel: (905) 877-4411

Distributed in the U.K. and Europe by David & Charles
Brunel House, Newton Abbot, Devon, TQ12 4PU,
England
Tel: (+44) 1626 323200, Fax: (+44) 1626 323319
Email: postmaster@davidandcharles.co.uk

Distributed in Australia by Capricorn Link
P.O. Box 704, S. Windsor NSW, 2756 Australia
Tel: (02) 4577-3555

Library of Congress Cataloging in Publication Data
Paillex, Laure
 Fresh and fabulous flowers in acrylics / Lauré Paillex.
 p. cm.
 Includes index.
 ISBN-13: 978-1-58180-976-3 (pbk. : alk. paper)
 1. Flowers in art. 2. Acrylic painting--Technique. I. Title.
ND1400.P33 2008
751.4'26--dc22
 2007030781

Edited by Jacqueline Musser
Designed by Clare Finney
Production coordinated by Greg Nock

ABOUT THE AUTHOR

Lauré Paillex has enjoyed drawing and painting all her life. As a child, her love for decorative art was inspired by the Peter Hunt folk art designs painted by her mother. Although largely self-taught, she has developed her skills through independent study, diverse art courses and associations with other professional artists. She has taught decorative painting for more than thirty years and has authored or contributed to twelve instruction books, several video lessons and numerous pattern packets. Her work is regularly featured in popular decorative painting magazines and has been licensed for the gift market.

Lauré is a business member of the Society of Decorative Painters and a member of the Graphic Artists Guild. She currently exhibits and teaches at locations around the U.S. and internationally as well as at her home studio, Cranberry Painter Decorative Arts. She and her husband, Andre, enjoy life in their antique farmhouse with saltwater and nature views of Cape Cod, Massachusetts.

Artist Contact Information
Lauré Paillex
P.O. Box 1495
Buzzards Bay, MA 02532-1495
Web Address: www.LaureArt.com

Metric Conversion Chart

To convert	to	multiply by
Inches	Centimeters	2.54
Centimeters	Inches	0.4
Feet	Centimeters	30.5
Centimeters	Feet	0.03
Yards	Meters	0.9
Meters	Yards	1.1

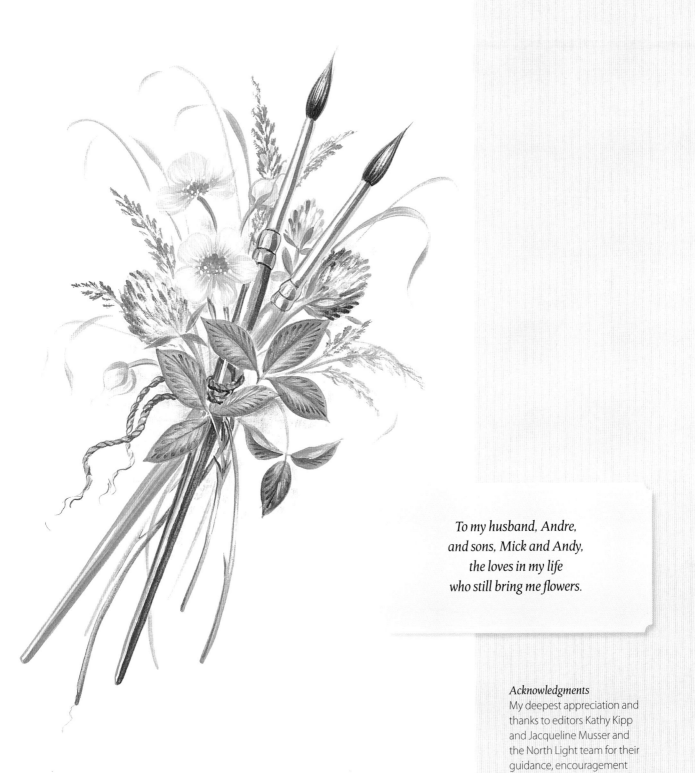

*To my husband, Andre,
and sons, Mick and Andy,
the loves in my life
who still bring me flowers.*

Acknowledgments
My deepest appreciation and thanks to editors Kathy Kipp and Jacqueline Musser and the North Light team for their guidance, encouragement and talents in helping bring the seeds of an idea into full blossom.

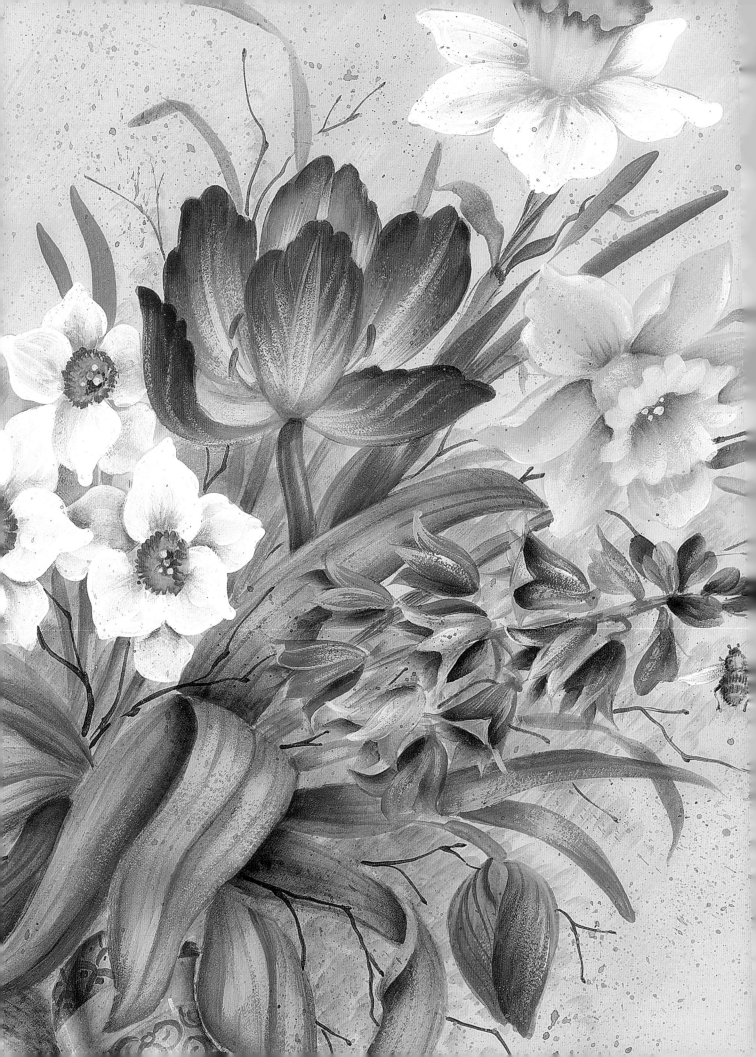

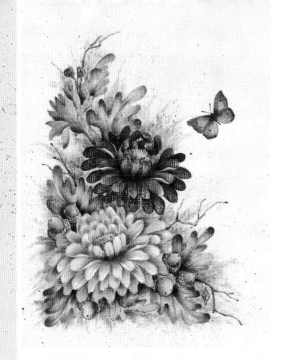

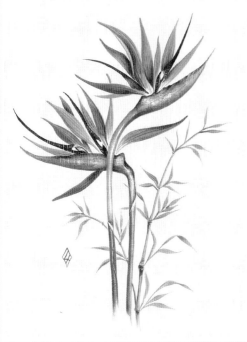

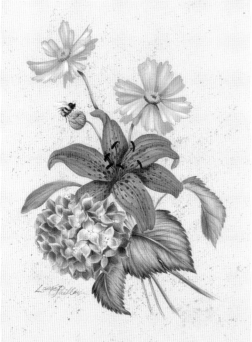

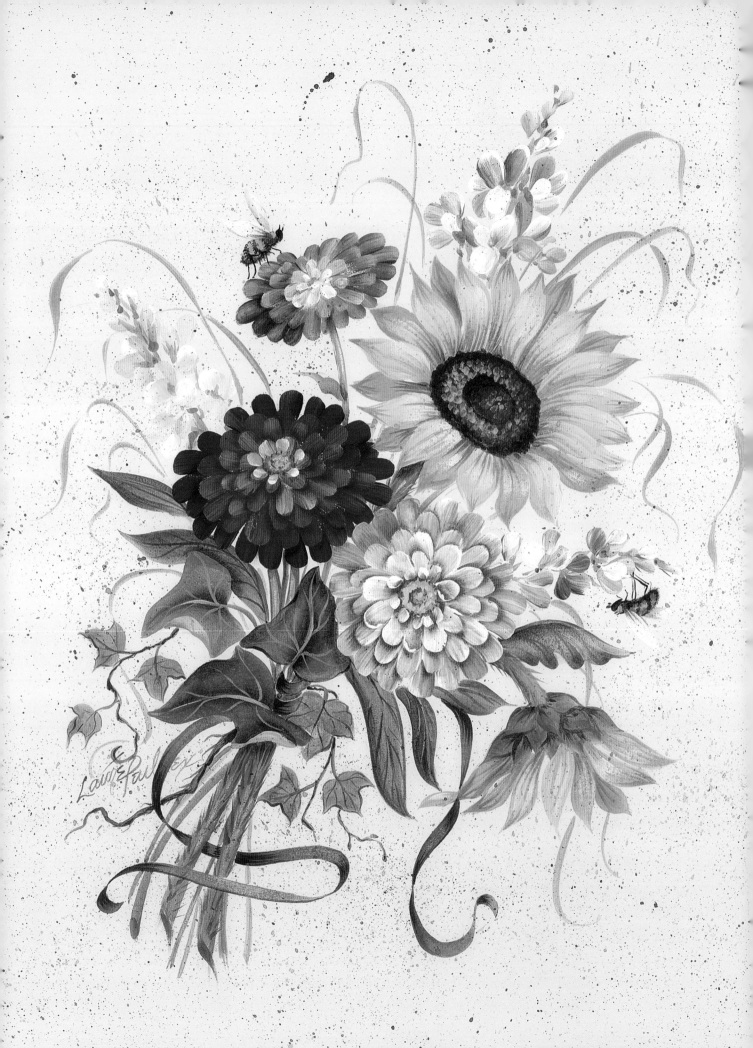

Introduction

My husband brings me flowers. Years ago, when we were courting, he would arrive at my door with a single sweet rose. Today, these tokens of his affection have blossomed into splendid bouquets for special occasions. Since life began in that first Garden, flowers have been praised in verse and song and immortalized by the artist's brush. Nothing communicates as sweetly, as colorfully, as sincerely, as flowers.

The studies in this book are designed to help you visualize just a few of the unlimited possibilities for arranging and rendering your favorite floral subjects. I encourage you to give yourself freedom to rearrange, alter or substitute any of the design elements, or to use your favorite medium or technique. Gather a collection of resource materials to use as "inspiration files" to help you generate ideas, and keep a sketchbook in which to play with composition and color possibilities. Set up a still life with blossoms plucked from your garden or gathered from a nearby field. Better yet, why not treat yourself to a beautiful bouquet of fresh cut flowers? It just might prompt memories of a long-ago romance ... still blooming sweetly after all these years.

"Flowers are the poetry of earth."
—SAMUEL COLERIDGE

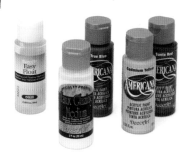

PAINTS

I used DecoArt Americana acrylic paints for the illustrations in this book (www.decoart.com). These are nontoxic, water-based acrylic paints sold in 2-ounce (60 ml) bottles. Shake the bottles well before using to make sure the binder is mixed with the pigments.

Acrylic paints can be thinned with water for strokework, linework or washes of color. There are several mediums available for thinning, blending and extending the drying time of the paint. You may wish to experiment with them. My favorite mediums are DecoArt Easy Float, used as a water conditioner, and a mixture of Easy Float and DecoArt Faux Glazing Medium, for use as a general painting medium. Follow the manufacturer's directions on the product label for uses and techniques. Acrylic paints and mediums are available at art and craft supply stores.

BRUSHES

The brushes used in this book are from Loew-Cornell, Inc., (www.loew-cornell.com).

High-quality Golden Taklon synthetic brushes are designed for painting with acrylics. With proper care, these tools will ensure the quality of your work. Never let paint dry in the brush, and rinse the brush often during your painting session. Clean thoroughly with a good brush cleanser, rinse well, and return the bristles to their original shape when you're finished painting.

The Series #244 Angular Bristle is a stiff, natural-hair brush that can be used for stippling techniques such as foliage backgrounds and certain textured flowers such as Queen Anne's lace. The Series #246 Bristle Rake Fan is ideal for applying textured background effects.

ADDITIONAL SUPPLIES

Tracing Paper — Tracing paper comes in pads or rolls in a variety of sizes and weights at art and office supply stores. Use it while developing your composition. Trace your final design onto tracing paper, and then use transfer paper and a stylus to trace the image on to your surface.

Transfer Papers — Transfer papers are most commonly found in gray and white. In this book, I've used a blue transfer paper called Super Chacopaper by Loew-Cornell. The blue lines disappear when wiped gently with a clean, wet brush or moist paper towel.

Stylus — This helpful tool often comes with a fine point on one end and a larger point on the other end. It is used to apply the pattern lines to your prepared surface.

Pencils, Colored Pencils and Art Pen — A supply of sharpened no. 2 pencils or mechanical pencils is helpful for sketching and tracing designs. I use a fine-point permanent ink art pen to execute the final version of a design. Colored pencils can be used to help visualize and experiment with a variety of color schemes.

Art Eraser — Use a polymer or kneaded eraser to remove telltale graphite transfer lines after the first layers of the painting are dry. The eraser can also be used to pick up the edges of dried masking fluid.

Loew-Cornell Brushes:
1. Angular Bristle #244
2. Rake Fan #246
3. Flat Wash #7550
4. Angular Shader #7400
5. Shader (Flat) #7300
6. Filbert #7500C
7. Short Liner #7350
8. Script Liner #7050
9. Mid-Liner #JS
10. Round #7000C

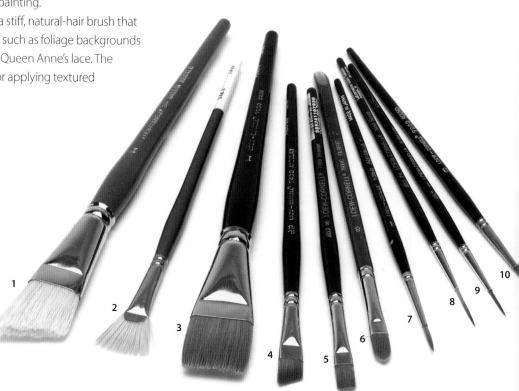

Water Basin — The Brush Tub II by Loew-Cornell has three sections that can be used as a clean water source and for rinsing brushes during and after your painting session. The largest section has ribs to help vibrate the area near the brush's ferrule, making paint removal easier. Always work in one direction: upward, following the angle of the ribs. Blot the brush on a clean paper towel to check if all the color has been removed.

Palettes — Since I like to arrange all my colors in spectrum order, I prefer to use a wet palette to keep the paints moist for long periods of time. Using a wet palette also makes it convenient to preserve my paints if my painting session is interrupted. I use a disposable dry waxed palette for all color mixing, brush loading and blending techniques.

Disposable Foam Rollers — I often use foam rollers for applying background colors. Choose rollers with a firm, dense texture to give an eggshell finish that is ideal for dry-brushing techniques. Unwashed, used rollers may be stored in airtight, ziplock bags for later use.

Masking Fluid — Liquid latex masking fluid can be used with acrylics on a variety of surfaces. It is usually colored with blue or orange dye so it can be easily seen after it dries. Apply masking fluid with a round brush that has been wiped across a bar of soap to protect the bristles. It's wise to set aside a brush exclusively for this purpose, because the brush will probably be ruined after introducing it to masking fluid.

Decorating Paste — You can make interesting textured backgrounds by mixing acrylic paints with decorating paste to the desired consistency. The thickened paint may be applied with a stiff rake/fan brush or with a tooth-edged graining tool. Wash tools and brushes with warm, soapy water immediately after use.

Graining Tool — A plastic, tooth-edged graining tool is used with thickened paint to create a variety of textured patterns. This tool may be purchased in the paint department at home supply stores.

Spatter Tool — An old toothbrush works well for spattering flecks of paint. There are also a number of specialty tools available for this purpose. The characteristics of the paint flecks will be determined by the paint consistency, the tool used, and the angle at which the tool is held in relation to the surface. Always test this technique before applying it to your painting!

Additional Materials:
1. Brush Tub II by Loew-Cornell
2. DecoArt Decorating Paste
3. Tracing Paper
4. Graining Tool
5. Super Chacopaper by Loew-Cornell
6. Disposable Foam Roller

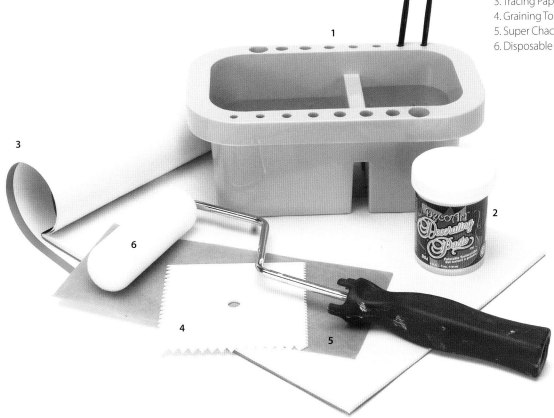

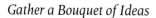

Gather a Bouquet of Ideas

Each of us possesses some measure of ability to express ourselves creatively. As we go about our daily lives choosing what to wear, deciding what to have for lunch or solving problems at work, we use the skills of observation, thinking, judging and decision making. We are engaged in the process of creativity. The steps in this process include: gathering information; generating lots of ideas; sorting and selecting; refining and improving; and executing the final plan.

In this section we'll explore these steps in a way that will help you create fresh and fabulous floral bouquets.

GET INSPIRED

Where to look for ideas. Gathering information is the first step in the design process. The best place to begin is in your own backyard … or in your neighbor's yard if she has a greener thumb! Even forests, fields and roadsides can yield a harvest of colorful blossoms, leaves and grasses for the artist. Many supermarkets carry fresh floral bouquets, and a trip to your local florist will surely provide lots of inspiration. If fresh flowers are not available, quality "faux fresh" blooms can be used for your still-life arrangement. Note which colors catch your eye and observe the varieties of texture, shape and size that make each element unique. Carry an unlined notebook or journal in which to record impromptu sketches and notes to use as a reference when you need a boost of inspiration.

Home and garden magazines and nursery catalogs are great resources for ideas. Store page clippings in transparent file folders arranged by color, season or theme. These resource files can also hold paint cards and sample swatches from your favorite paint and wallpaper outlet. A trip to your local office supply store will provide you with many great options for keeping your files attractively organized.

There are numerous books available specifically for use as reference material for the artist. You'll want to build a library of titles that reflect your interests. My book *Fast & Fun Flowers in Acrylics* offers step-by-step instructions on painting more than sixty different flowers. Other great floral reference books include: *Painting Four Seasons of Fabulous Flowers* by Dorothy Dent; *Artist's Photo Reference: Flowers* by Gary Greene; *Painting Flowers A to Z with Sherry C. Nelson MDA*; and *Painter's Quick Reference: Flowers & Blooms* by the Editors of North Light Books.

Your computer and the Internet are marvelous tools for researching, collecting, organizing and storing information and ideas. Bookmark your favorite inspirational Web sites or search for photos of specific flowers. Your files can be stored on your computer or transferred to a CD (compact disc) for portability. Please remember that materials downloaded from the Internet enjoy the same copyright protection as printed and recorded matter.

Remember, inspiration can come from the most unexpected sources, so train your eye to be alert for colors, shapes, textures and themes that appeal to your unique sense of style.

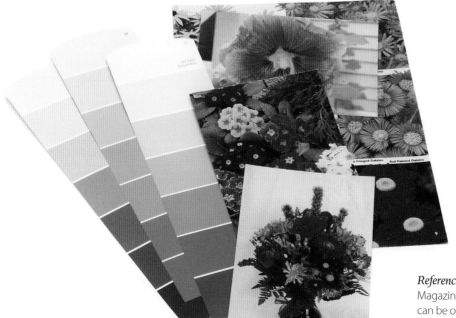

Buds of Inspiration

"I have more ideas in my head than I could ever carry out…"

—VINCENT VAN GOGH

Reference Materials
Magazine and catalog clippings, photos and color swatches can be organized into clear file folders for visibility and easy access. These resource files can be sorted for use with a specific project or used to generate new design ideas.

Explore Flowers Through Photography

Digital photography provides painters with the ability to instantly record, edit and print subjects for use as reference material. Today's cameras are small enough to carry in a pocket or purse, and, with automatic "aim and shoot" features, they are easy to use. Many models are relatively inexpensive, and photos can be printed with a simple photo printer or docking station. Most home computers come with preinstalled photo-editing software, which allows photos to be adjusted and printed from your home desktop. Some programs even come with special-effects features that can transform your images into the look of watercolor, pastel or colored pencil. Internet photo developing services or DIY (do-it-yourself) kiosks in retail stores are also widely available. Your photographs can be stored as prints in a conventional album or as photo files on a compact disk for viewing on your computer. Search your favorite bookstore for titles about the basics of digital photography. (*101 Great Things To Do With Your Digital Camera* by Simon Joinsen and *100 Ways to Take Better Photographs* by Michael Busselle are two good books on the topic.)

Remember, these photo images are merely references to use as painting aids. Although quality pictures are a great resource, photo prints and digital images on a computer screen cannot compare to the rich, pure colors of nature found in quality artist's pigments.

Here's a list of materials you will need for taking reference photos:
- Digital camera
- Indirect natural light or artificial light source
- Digital photo printer and/or computer with photo-editing software
- Tripod for stability
- Foam core tripanel presentation board (as a stand-up background)
- Background material – light-colored sheet or bath towel

Tips for Reference Photography

- Avoid busy backgrounds that might be confusing.
- Hold the camera still or use a tripod to prevent blurry images. Press your elbows against your sides to steady the camera.
- When shooting outdoors, overcast daylight is ideal. If shooting in bright light, keep the sun at your back.
- Use your camera's largest file size and highest resolution to capture the finest details.

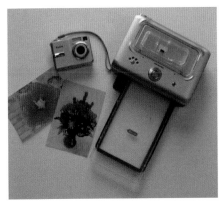

Photography Equipment
A digital camera enables painters to instantly record, edit and print subjects for use as reference when planning a composition.

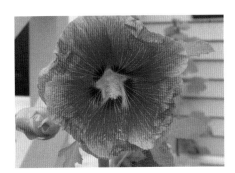

Good Photo
This photo is good because it is in focus and shows sharp details and strong contrast.

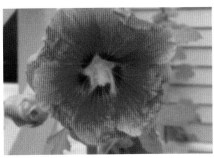

Bad Photo
This photo is poor because it is out of focus and the image is blurred.

Buds of Inspiration

"Instead of trying to reproduce exactly what I have before my eyes, I use color more arbitrarily, in order to express myself more forcibly."
—VINCENT VAN GOGH

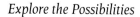
Explore the Possibilities

Most of us can recognize a good design when we see one, and we can sense when something isn't "just right" as well. Good composition consists of a balance between shapes, spaces, visual weight and line. Other elements such as texture, color and style will vary depending on the individual project or the artist's personal taste.

Once you have gathered your resource materials or set up a still-life model, you're ready to make a few preliminary compositional sketches. Remember, your goal is not to copy exactly, but to experiment, observe and determine what works for you.

Here are some helpful hints for engaging in the design process:
- Be playful! Have fun experimenting and making lots of sketches.
- On a separate piece of paper or in your sketchbook, draw several small shapes representing the general overall shape of your design. Use these initial thumbnail shapes to record your thoughts as you explore many design options.
- Don't erase. Draw quickly and lightly, making revision lines directly on top of your initial drawing or overlay with a fresh piece of tracing paper.

- Begin with basic lines and shapes representing objects that vary in size and shape.
- Use odd numbers of objects—three, five, nine, etc.—to create visual balance.
- Draw through each shape completely. Overlap objects to create the illusion of perspective.
- Pay attention to the size of objects in relation to each other.
- Don't be afraid to make mistakes.

Here's a list of materials needed for making sketches:
- Pencils. Mechanical pencils are great because a fresh point is always a click away.
- Tracing paper. An inexpensive weight is best.
- Colored pencils or markers. These are good for planning color layout.

What is a "Thumbnail"?

A thumbnail is a small, rough sketch that captures an idea at the moment of inspiration. I call these quick little sketches "brain droppings!"

Buds of Inspiration

"Doodle, doodle
Shape and form;
That's how great
Designs are born!"

Take Your Sketch to the Next Level

Once you're satisfied with the rough composition, it's time to take your design to the next level by editing, rearranging and refining the elements. Does a certain flower need to be flipped or rotated? Should leaves or stems be overlapped or reshaped? Could filler be used more effectively? These adjustments can be easily accomplished by placing layers of tracing paper over the original sketch as you develop and perfect your composition.

Refine the basic shapes into individual flowers. Purposefully place secondary items such as vines, filler foliage and butterflies to interact with the major design elements. Consider the shape of your background surface and adjust your composition to rest gracefully within that area. You will learn more about how to determine the basic shape of a design surface and visualize the compositional possibilities later in the book (see pages 16 – 19).

Decorative painters, who often work on functional, three-dimensional objects, must consider several factors before deciding on a composition layout. Does the piece have any hinges, knobs or cutouts that might affect the flow of the design? Will any part of the design be hidden when the finished piece is being used? Once you've chosen your surface, trace the area to be decorated, taping pieces of paper together if needed to include the entire outline. Indicate the placement of any peculiar elements such as hinges or knobs. Place layers of tracing paper over the original sheet as you develop and perfect your composition.

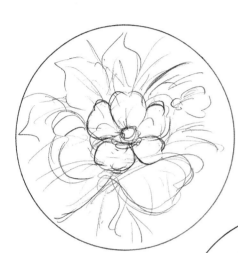

Thumbnail Sketches
These are quick, rough drawings that express ideas.

Preliminary Sketches
Use basic lines and shapes to plan your drawing.

Final Painting
Merry and Bright, see pages 30–31.

Final Drawing Phase
Use colored pencils to help guide your palette.

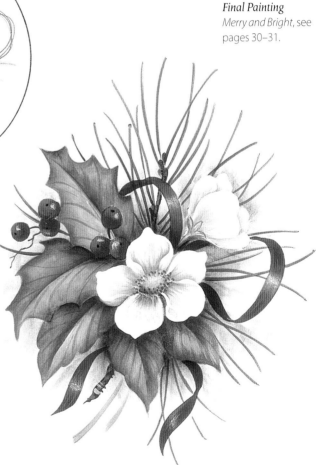

Create a Palette That Expresses Your Personality

Color is the most important tool painters use, and it's the first thing that draws a viewer's attention to the subject. Although you could spend years studying the volumes written about color theory, choosing a pleasing palette for your floral composition doesn't have to be complicated. You can begin by using the materials in your inspiration files as a clue to your personal palette preferences.

What color combinations attract your eye most often? Perhaps you have a seasonal theme in mind. How does an early spring palette differ from an autumn one? If you will be painting on a furniture piece, how will your color choices interact with the other colors and styles in the room? Do you have the freedom to create the painting for yourself, or is your work being commissioned for someone else to enjoy? These questions can be used as starting points before choosing the actual colors, but the most important rules are to trust your judgment and paint what you love. Since each of us sees and reacts to color in a very personal way, your actual color choices will reflect your unique style and personality. That is the joy of painting!

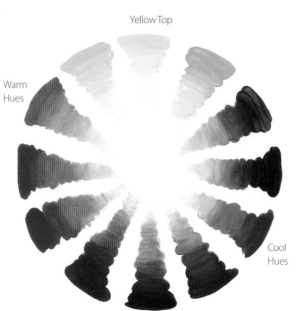

Yellow Top

Warm Hues

Cool Hues

Tertiary Colors

Raw Sienna or Honey Brown

Burnt Sienna

Burnt Umber

Payne's Grey (transparent blue-black)

Color Wheel With Tints
This color wheel illustrates how each of our palette colors changes in value and intensity when white is added, resulting in a tint. A similar chart could be made by mixing each original hue with a neutral color such as Light Mocha, resulting in a toned palette.

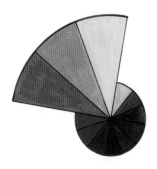

Analogous Harmony Diagram
Analogous bouquets are dominated by tints, shades and tones of colors that rest side by side on the color wheel. Accents of complementary colors bring sparkle and balance to the arrangement. (See *October Fire*, page 41.)

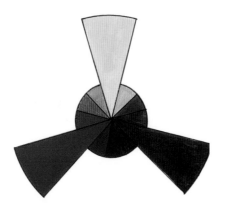

Triadic Harmony Diagram
Triadic harmonies are naturally balanced since they use any three hues that are equally spaced from each other on the color wheel. (See *Rainbow Mix*, page 72, and *Exotique*, page 58.)

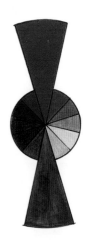

Complementary Harmony Diagram
Complementary schemes use colors that are opposite each other on the color wheel. A color placed next to its complement will appear brighter. (See *Merry and Bright*, pages 30–31.)

HOW BACKGROUND CHOICE AFFECTS COLOR

Your entire painting will be affected by your choice of background color. In some instances your flower colors will determine the background; at other times your predetermined background will dictate your flower palette. Always remember that everything is in relation to what is around it. You may find it helpful to keep a collection of 4" × 6" (10cm × 15cm) cards in your favorite background colors as a visual reference when planning a color scheme. Use a small amount of background color on your palette as a toner to unify your flower colors with the background.

When choosing a background color, consider the following:

- A warm background pushes cool colors forward.
- A cool background pushes warm colors forward.
- A complementary background will make your palette colors appear brighter.
- Use background colors to support the center of interest in your painting by planning contrasts between areas of light and dark, warm and cool.

- Choose the second- or third-most dominant color on your palette, and then lighten or tone it for use as a background.
- Always test your colors against the background color.
- Use your background color to tone your palette colors.

In the illustrations below you can see how the background color affects the visual properties of the flower colors.

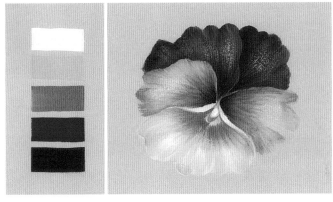

Cool Background
This cool, light purple background pushes the pansy's warm yellow colors forward.

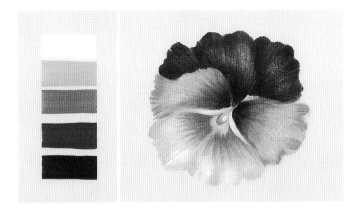

Warm Background
This warm, toned yellow background pushes the pansy's cool blue colors forward.

Color Terminology

Here are a few basic terms that will be helpful for you to understand when choosing your color palette:

- *HUE: labels the most basic name of the color—red, blue, yellow-orange, etc.*

- *VALUE: describes how light or dark a color is.*

- *INTENSITY: indicates how bright or dull a color is. High-intensity hues are bright and pure. Low-intensity hues are dulled by the addition of other colors.*

- *TEMPERATURE: relates to how warm or cool a color is. Each color on your palette can have a warm and a cool aspect determined by its placement on the color wheel. Warm colors seem to advance. Cool colors recede.*

- *A TINT is made by adding white to a color, thereby increasing its value.*

- *A SHADE is made by darkening a color with the addition of its complement or black.*

- *A TONE is a color that has been "grayed" or dulled by adding a tertiary color or an actual gray value. Be aware that toned colors can make your flowers look dull and lifeless.*

Identify and Choose an Arrangement Shape

Composition is the process of taking several basic elements and arranging them into a unified, well-balanced, visually pleasing motif. For many artists, this is the most challenging aspect of design, but as we learn to assess the characteristics of a surface and visualize the possibilities, the task of making a graceful arrangement becomes less intimidating. As always, remember not to be slavish about adhering to a set of rules, but trust your instincts and feel free to play and experiment.

Let's look at some basic surface formats and design layouts. Before you begin putting the pieces of your arrangement together, study your surface to determine its inherent shape. This will help you decide which compositional motif to choose.

Paul Cézanne observed that all forms in nature can be reduced to a few basic shapes. The circle/sphere, square/cube and triangle/pyramid can be recognized in the surface format as well as in the actual design elements. These shapes together with the principles of line, form, color and texture are an artist's primary tools.

SQUARE, RECTANGULAR & LINEAR ARRANGEMENTS

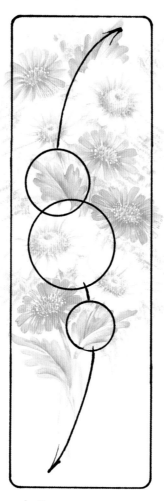

Rectangular Layout
This can incorporate both linear and "S"-curve designs. See *Sweet and Simple* on page 34 and *Fresh as a Daisy* on page 40.

What is a "format"?

Format refers to the overall size and shape of the area in which a composition is to be arranged.

Rectangular "S"-Curve Motifs
Graceful stems can be used to direct the viewer's attention. See *A Brush of Color* on page 38.

Square Layout
Although uncommon, an interesting composition can be created within a 90-degree format. See *Autumn Glory* on page 96.

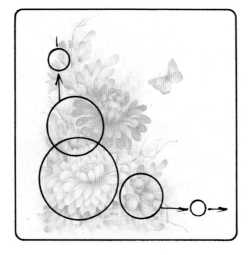

Using Layout Styles

Once you've determined the perimeters of your surface it's time to explore various design options. As you will see, the most pleasing layouts are in harmony with the size, shape and contours of a given format.

• A RADIAL LAYOUT bears the visual weight at its center and utilizes elements that decrease in size as they radiate outward, giving a starburst effect. This style can be used effectively with most background shapes.

• A CRESCENT LAYOUT is formed in the shape of a "C" and can have its focal point anywhere along the central line as needed for balance. This layout works best in circular or organic formats.

• An "S" LAYOUT carries the eye along a graceful "S" curve with the elements balanced along the central line. Tall, narrow bouquets and beautiful borders can be created with simple "S" curves.

• An ANGULAR LAYOUT can be used with a square, triangular or other geometric shapes.

• LINEAR LAYOUTS can be symmetrical, asymmetrical or "S"-curve motifs, such as garlands or swags, and are often repeated for borders.

Reducing the main objects in your design to a few basic shapes helps you arrange the pieces into a simple pattern that complements the surface area. In the illustrations on pages 16–19, the design flow is indicated by lines and arrows. The focal point is represented by the largest circle and the secondary elements in decreasing sizes for balance.

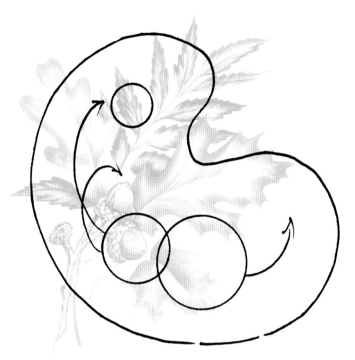

Unconstructed. Unconstructed arrangements are balanced by the use of form, space, line and color. See *October Fire* on page 41.

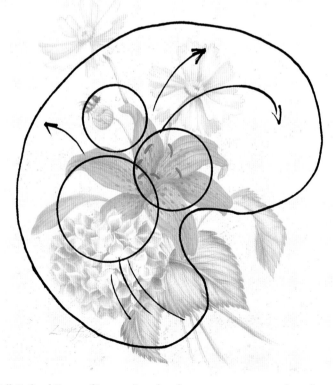

Well-Defined Center of Interest. Even free-form arrangements need a well-defined center of interest. See *Backyard Beauties* on page 50.

CIRCULAR ARRANGEMENTS

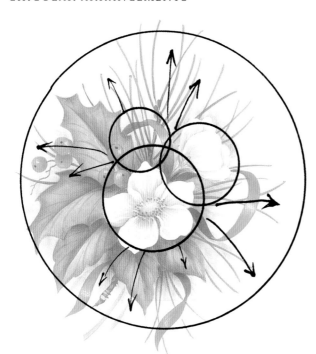

Radial Layout
This view is similar to looking down onto a round surface. See *Merry and Bright* on pages 30–31.

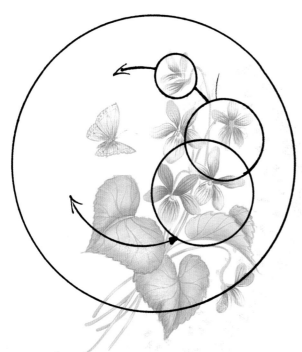

Another Crescent Layout
This is another example of a crescent layout. See *Sweet Violets* on page 24.

What is the "focal point" of a painting?

The focal point, or center of interest, is the area that first attracts the viewer's eye and holds his attention. This area contains the most dominant element in the design as well as the greatest color intensity, value contrast and detail.

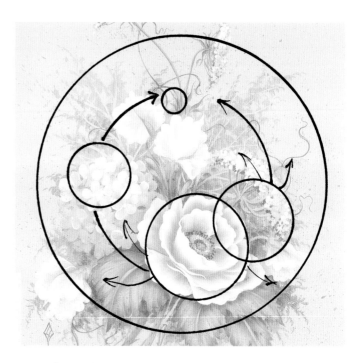

Crescent Layout
The focal point rests anywhere along the main curve. See *Cottage Garden* on page 104.

Buds of Inspiration

"In painting, as in the other arts, there's not a single process, no matter how insignificant, which can be reasonably made into a formula. You come to nature with your theories, and she knocks them all flat."

—AUGUSTE RENOIR

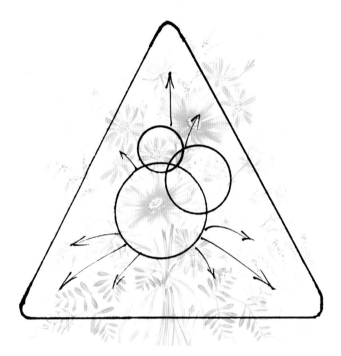

Radial Layout
The focal point is near the center, and elements radiate outward to form a triangle shape. See *Country Roads* on page 42.

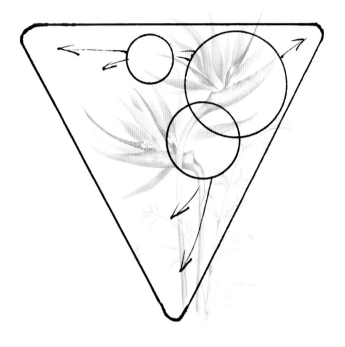

Angular Layout
The visual weight is located in one corner for a modern look. See *Exotique* on page 58.

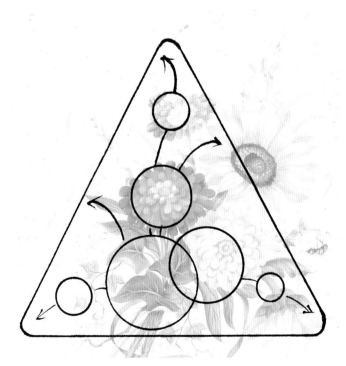

"S"-Curve Layout
Another classic design motif. See *Rainbow Mix* on page 72.

Guidelines for Good Composition

- *Allow the surface shape to suggest the design layout.*

- *Use basic lines and shapes to visualize the layout possibilities.*

- *Keep elements with the greatest visual weight at the center of interest. Visual weight refers to the perceived size and volume of objects in relation to each other.*

- *Aim for contrast and variety in the size, shape and texture of the design elements.*

- *Use negative space creatively. Negative space is the open area around the elements.*

- *Use stems, vines and tendrils to direct the viewer's attention throughout the composition.*

- *Use odd numbers of objects—three, five, nine, etc.—to create asymmetrical balance.*

Create Medium Mix. (See the photo at right) I like to use a mixture of DecoArt Faux Glazing Medium and Easy Float in my brush to help with strokework, linework and washes of color. I refer to the mixture as medium mix throughout the step-by-step demonstrations.

To create this mixture, place a small puddle of Faux Glazing Medium on your palette and add one or two drops of Easy Float.

Dress and Load the Brush. (See the photo at far right) Work medium mix into the brush. Drag one corner of the brush into the paint and pull the paint out into a thin loading zone.

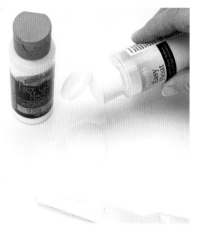

USING MASKING FLUID

Masking fluid helps you preserve delicate details and edges while painting backgrounds and surrounding areas. You can paint right over the masking without affecting the surface underneath. I reserve a round brush exclusively for this task because the fluid can ruin a brush.

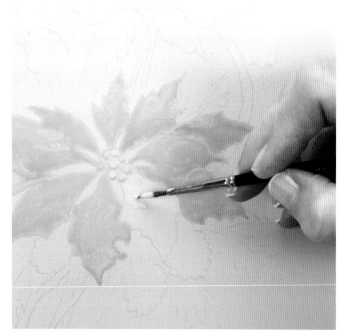

1. Apply masking fluid. Dampen a brush and run it across a bar of soap to help protect the bristles. Dress the brush with masking fluid. I use blue masking fluid because it is easy to see where I have applied it, but it does not leave any color on the surface. Pay close attention to stay within the lines of your tracing, especially near the edges. Rinse the brush in water and reapply soap as needed. Let dry before you begin painting the surrounding areas.

2. Remove masking fluid. Lift the edges of the masking fluid gently with an art eraser, and carefully pull the mask from the surface. Tidy the edges with the eraser. Dust away particles with a clean, dry paper towel.

SPATTERING

Spattering is an easy way to embellish your background.

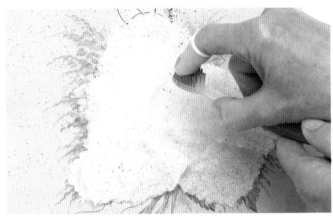

1. Cover painting, load brush. Tear a paper towel into large pieces, rounding the edges to match the layout of your design. Cover all the major elements in the design.

Work paint into a toothbrush or any large, stiff brush.

2. Spatter paint. Flick the paint onto the surface by running your finger or a palette knife over the brush. Repeat with as many colors as necessary.

For the final color, remove the paper towel and add fine, controlled spatters to selected areas of the painting.

CREATING A SQUARE EDGE

Some flowers, such as the chicory in *Country Roads* (page 42), have square petals, so you need to create that shape with your brush tip.

1. Load. Load any round or liner brush and flatten the bristles on your palette.

2. Make flat strokes. Pull long, flat strokes inward from the outer edge.

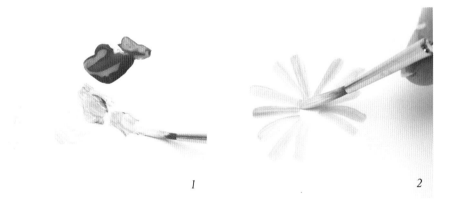

1

2

RAFFIA HIGHLIGHT

This method of highlighting can be used on any ribbon.

1. Basecoat and shade. Base the ribbon with thin-thick-thin strokes using a flattened liner brush. Line the shaded edges with a darker value where the ribbon would twist or turn. Then drybrush lighter planes with a flattened brush.

2. Highlight. Highlight the center plane again with a lighter value of the color you drybrushed in step 1.

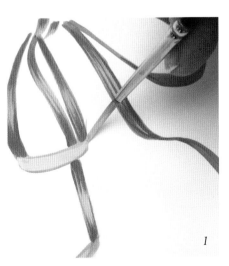

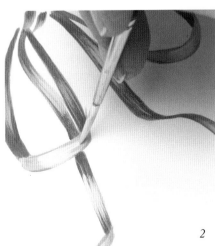

1

2

PIVOT FLOAT

Use pivot floats to illuminate round objects, such as the egg in
Think Spring (page 78).

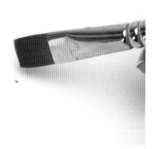

1. Center pivot. Make a dot that will be the center of the pivot.

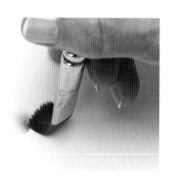

2. Make first turn. Pivot the brush 180 degrees.

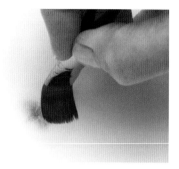

3. Make second turn. Reposition the brush and pivot the brush another 180 degrees in the opposite direction.

TEXTURING A BACKGROUND

Use acrylic paint thickened with DecoArt Decorating Paste and
a stiff rake/fan brush or a tooth-edged graining tool to create
wonderfully textured background. This first textured background
is used with the *Exotique* project (page 58).

1. Basecoat and apply texture. Basecoat your surface with Light Mocha. Then mix a generous amount of Light Mocha with DecoArt Decorating Paste. The mixture should be about 4:1, paint to paste. Mix with a palette knife until smooth and about the consistency of brownie batter. Allow the mixture to thicken slightly. Use a dry, stiff-bristle fan brush to apply a heavy coat of the thickened color.

Create a deeply textured woven pattern, with the texture alternating in rows of vertical and horizontal strokes, similar to a basket weave. These raised ridges of paint are an integral part of the design and are necessary for bringing out the dry-brushed layers.

2. Drybrush with Warm White. When the background is thoroughly dry, pick up Warm White across the width of a 1-inch (25mm) angular bristle brush and remove excess paint by swirling the bristles on a dry piece of palette paper. Using diagonal crosshatch strokes, lightly drag the brush across the surface to deposit paint on the raised texture. Gradually build up dry-brushed layers, painting until the texture pattern is clearly visible.

This textured background is used with *Autumn Glory* (page 96).

1. Basecoat and apply texture. Basecoat your surface with Light Mocha. Then mix a generous amount of Light Mocha with DecoArt Decorating Paste. The mixture should be about 4:1, paint to paste. Mix with a palette knife until smooth. It should be about the consistency of brownie batter. Spread the mixture evenly across the surface using the smooth side of the tooth-edged graining tool.

While the paint is wet, drag the fine-tooth edge vertically across the surface, creating ridges that resemble corduroy fabric. Wipe the tool clean often. You can go over the surface as often as needed to achieve your desired texture. You have about ten minutes of open time with this mixture.

2. Drag graining tool horizontally. Drag the fine-tooth edge horizontally across the surface to create the look of textured, woven fabric. Let dry. Clean your tooth-edged graining tool with soap and water and a scrub brush to remove the paint, especially from the fine-tooth area.

3. Drybrush with Warm White. When the background is thoroughly dry, pick up Warm White across the width of a 1-inch (25mm) angular bristle brush and remove excess paint by swirling the bristles on a clean, dry palette. Using diagonal crosshatch strokes, lightly drag the brush across the surface to deposit paint on the raised texture. Gradually build up dry-brushed layers until the textured pattern is clearly visible.

A Simple Composition of a Violet Bouquet

Sweet violets, with their shy, nodding faces, represent modesty and faithfulness. The subtle lace doily background adds old-fashioned charm to this delicate bouquet.

For the background detail, choose a paper lace doily that has generous open spaces in its cutwork border. Cut out sections of lace and lay them onto a prepared, light-colored background. Using a fine-textured sponge, tap a color slightly darker than the background over the doily to create the lace image. Here, I've used Soft Lilac against a white background.

"The violet's charms I prize indeed, So modest 'tis and fair."

—JOHANN WOLFGANG VON GOETHE

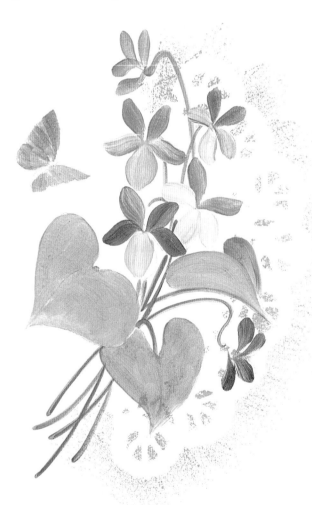

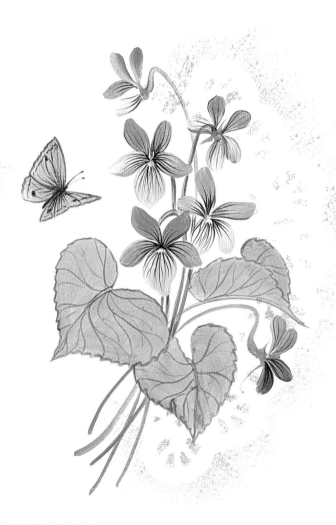

1. Place the initial colors. Place the initial colors with form-following strokes using slightly transparent paint. Dressing your brush with a small amount of medium mix (page 20) will help the paint flow evenly onto the surface.

Base the leaves with Olive Green using a no. 4 filbert.

Stroke in the stems with a no. 4 liner using Honey Brown, Olive Green and Forest Green mixtures for a variety of greens.

Paint the violet petals a variety of light- and middle-value purple mixtures created from Snow (Titanium) White, Dioxazine Purple, Blue Violet and Napa Red to develop a range of blue-violet and red-violet hues. A no. 4 liner or a small filbert brush is ideal for executing petal strokes. Note that the two darker top petals are painted first and the side and front petals follow in a lighter value.

Place the butterfly with thinned Honey Brown.

2. Define the details. Use appropriately sized liner brushes and thinned paint for the finest details.

Paint the veins and serrated edges on the leaves using Forest Green and a no. 1 mid-liner.

Paint the flower petal veins with Dioxazine Purple + Blue Violet and Napa Red mixtures using a no. 10/0 mid-liner. Pull these strokes from the base of the petal outward following the curve of the petal.

Execute the butterfly details with a no. 10/0 mid-liner using a dark brown mixture of Honey Brown + Dioxazine Purple.

Materials List

Brushes: nos. 4 and 8 flats, no. 4 filbert, no. 4 liner, nos. 1 and 10/0 mid-liners

DecoArt Americana Acrylics: Snow (Titanium) White, Cadmium Yellow, Dioxazine Purple, Blue Violet, Napa Red, Olive Green, Forest Green, Honey Brown, Soft Lilac

Additional materials: medium mix (page 20)

Pattern: see page 124

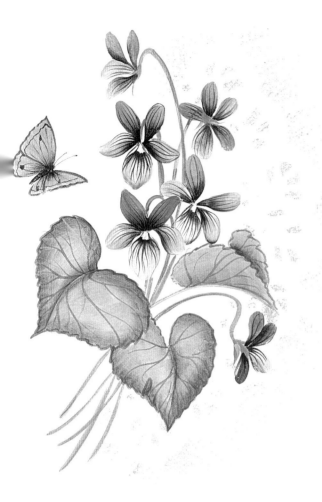

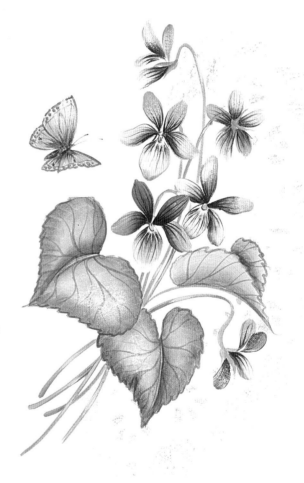

3. Develop the shading. Place shading values with floated color using appropriately sized flat brushes (nos. 4 and 8), dressing the brush with a small amount of medium mix to facilitate the color flow.

Shade the leaves along outside edges and down the center veins with a dark green mixture of Forest Green + a touch of Blue Violet.

Shade the base of each petal with the color used for the veins. Leave white space at the throat where the pollen center will be placed.

For the butterfly, float on the thinned dark brown mixture from step 2.

Tip of the Brush

When using a monochromatic color scheme, employ a range of light to dark values as well as warm and cool hues to achieve dimension, interest and contrast throughout the design. A touch of complementary color (such as the yellow used with the violets in this demo) adds a sparkle of light.

4. Add the final details and highlights. Highlight the violets' throats with Snow (Titanium) White using a side-loaded no. 4 flat. Place the pollen center with a tiny raised dot of Cadmium Yellow and orange (brush-mix of Cadmium Yellow + a touch of Napa Red) using the no. 10/0 mid-liner. Drybrush a soft white highlight at the center of each front-facing petal using a no. 4 filbert.

Drybrush raised areas on the leaves and stems with a mixture of Snow (Titanium) White + a touch of Olive Green using a no. 4 filbert.

Add tiny orange dots to the edges of the butterfly's wings. Highlight the large wing only with a dry-brushed stroke of Snow (Titanium) White.

A Simple Composition of a Purple Coneflower With Butterfly

The simplest idea can make the most delightful painting when you choose colors, shapes and lines that set a mood and tell a story. Here, I've use the yellow-red-blue triad, the rounded shapes and curved lines to carry viewers to a sunlit garden on a warm summer day. Our winged friend must feel as though he's sitting on top of the world!

"O, there is nothing holier in this life of ours than the first consciousness of love — the first fluttering of its silken wings."

—HENRY WADSWORTH LONGFELLOW

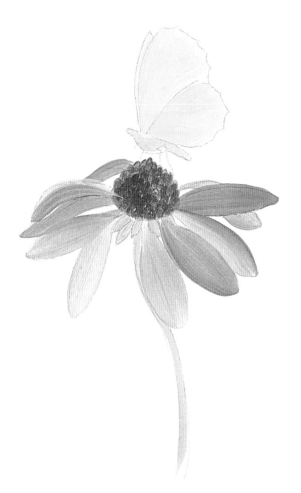

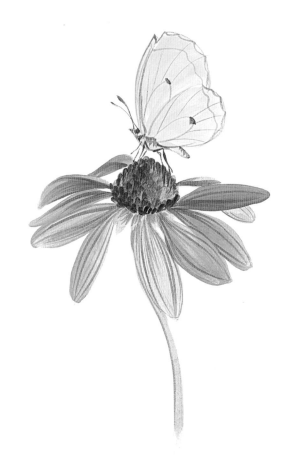

1. Place the initial colors. Place the initial colors with slightly thinned paint, carrying a little medium mix (page 20) in your brush to facilitate the paint flow. Use appropriately sized brushes according to the size and shape of the area being painted.

Stroke the stem and little sepal petals with Olive Green using a no. 4 liner.

Base the butterfly with a light yellow mixture of Cadmium Yellow + Snow (Titanium) White and the no. 4 flat.

Develop the petals with a variety of soft pink hues created by mixing Snow (Titanium) White + Napa Red using a no. 4 round or a no. 4 liner. Depending on the size and shape of the petal, two strokes may be required to fill the area.

Pat the flower center with Burnt Sienna using the point of a no. 4 round.

2. Develop the details. Use nos. 1 and 10/0 mid-liner brushes with thinned paint to add details and outlines. Lines are also used to indicate shaded areas such as at the base of the flower petals and along the stem.

Shade along the left edge of the stem with a mixture of Olive Green + Forest Green.

Vein the flower petals with contrasting pink values using mixtures of Snow (Titanium) White + Napa Red.

Use Burnt Sienna to paint the wing veins and outlines on the butterfly. Use Burnt Umber for details on the body, legs and antennae.

Add dabs of Burnt Umber with the point of a no. 4 round to place a textured shadow on the flower center.

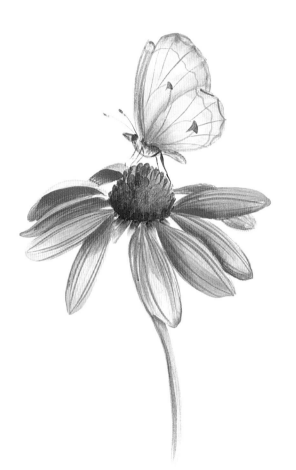

Materials List

Brushes: no. 4 round; nos. 4, 8 and 12 flats; no. 4 liner; nos. 1 and 10/0 mid-liners

DecoArt Americana Acrylics: Snow (Titanium) White, Cadmium Yellow, Napa Red, Olive Green, Forest Green, Burnt Sienna, Burnt Umber, Blue Chiffon, Blue Violet

Additional materials: medium mix (page 20)

Pattern: see page 124

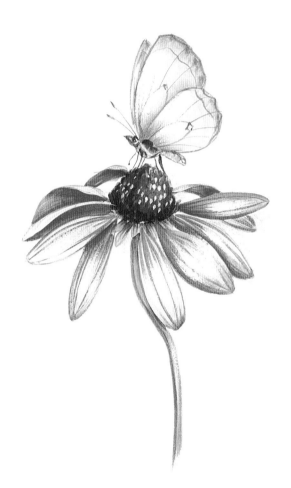

3. *Place the shading values.* Add shading with floated color using appropriate sized flat brushes (nos. 4, 8 and 12). Using medium mix facilitates the paint flow and helps prevent the color from spreading too far across the brush width.

Shade the stem and sepal with a dark green mixture of Forest Green + a touch of Blue Violet at the base of the sepals, along the left side of the stem and as a cast shadow under the flower petal.

Shade the flower petals with a thin wash of Napa Red at the base of each petal and also to separate individual petals. Study the flower to discern which petal edges are in shadow.

Tint the butterfly at the base of the wings and around the outside edges with an orange mixture of Cadmium Yellow + a touch of Napa Red. Separate the wing edges with thinned Burnt Sienna. If needed, strengthen the details on the body with Burnt Umber.

Float Burnt Umber around the lower edge of the center cone.

Tip of the Brush

Let your brushstrokes flow with the direction and shape of each petal, exerting and releasing pressure on the brush to create natural form and movement.

4. *Add the final details and highlights.* Sparkles of undiluted, opaque white reflect light and bring your painting to life.

Drybrush Snow (Titanium) White highlights on the butterfly wings and at the centers of top-lying petals using a "flattened" round brush.

Add bright dots of white to the butterfly's wing spots and to its eye with a fine liner.

Place pollen highlights with dots of Cadmium Yellow followed by Snow (Titanium) White.

If you are working on a white or pale blue background you may choose to pat in some soft blue color behind the flower to represent sky. Here, I used a mixture of Blue Chiffon + a touch of Blue Violet side-loaded on a no. 12 flat. Lightly moisten the background with a drop of medium mix before you add paint to aid in blending and fading the color to the desired intensity.

A Simple Composition of Dandelions in a Bottle

What mommy cannot recall a smiling freckled face, a chubby little hand clutching a soft, golden love offering?

In the language of flowers, dandelions represent "wishes come true."

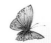

"Life is the flower for which love is the honey."

—VICTOR HUGO

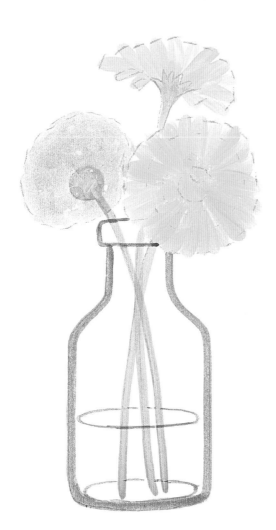

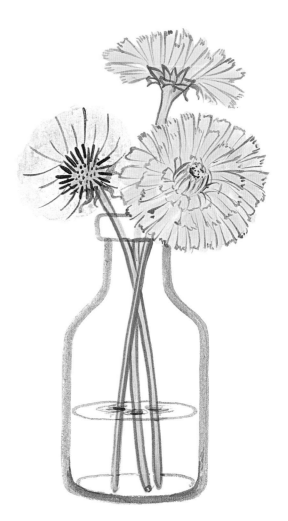

1. Place the initial colors. Establish the stems and flowers before placing the bottle outline with transparent color. Note that the width of the bottle's outline represents the thickness of the glass.

Stroke the stems with Olive Green using a flattened no. 1 mid-liner (see *Creating a Square Edge*, page 21).

Paint the dandelion petals using a no. 4 filbert loaded with a mixture of Cadmium Yellow + a touch of Snow (Titanium) White. Pull individual petals inward from the outside edges toward the center.

Paint the bottle using a mixture of True Blue + Black Forest Green (2:1). Use paint thinned with medium mix and a no. 4 liner for the top rim and the outside edges. Carefully outline the ellipses, which indicate the water line and the inside of the bottle base.

Lightly brush the puffball with a thinned amount of the blue mixture from the bottle + a touch of Burnt Umber + a touch of Snow (Titanium) White (this creates a silver-gray hue). Dab the wet paint with your fingertip to produce a mottled, semitransparent effect.

2. Develop the details. Outline the stems and sepals with a mixture of Black Forest + Olive Green (2:1) using a no. 1 mid-liner.

Lightly outline all yellow flower petals with a thinned mixture of Cadmium Yellow + Burnt Sienna using a no. 10/0 mid-liner. Note the unique, ragged, square shape of the dandelion petals and the way the center folds together into a cluster. Place the puffball seeds and flower-head details with Burnt Umber and add the filaments with fine lines of the gray mixture from step 1.

For the water, place fine, concentric circles of the blue-green mixture where each stem breaks through the surface of the water.

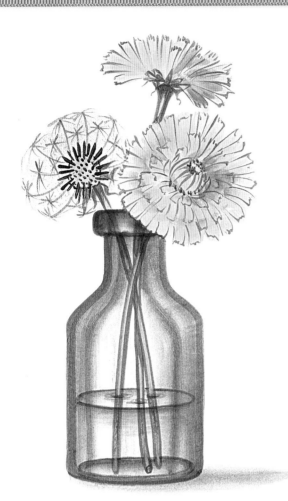

Materials List

Brushes: nos. 4, 8 and 10 flats, no. 4 filbert, no. 4 liner, nos. 1 and 10/0 mid-liners

DecoArt Americana Acrylics: Snow (Titanium) White, Cadmium Yellow, True Blue, Olive Green, Black Forest Green, Burnt Sienna, Tangelo Orange, Burnt Umber

Additional materials: medium mix (page 20)

Pattern: see page 124

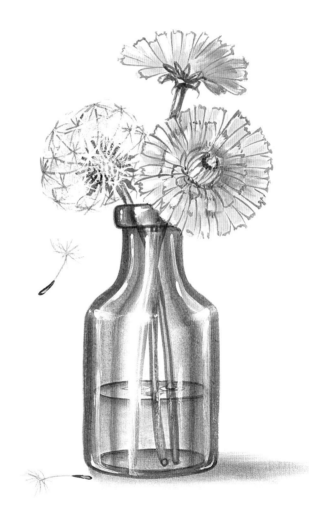

3. Place shading values. Line the stems and sepals along underlying edges and down one side of each stem with a mixture of Black Forest Green + a touch of bottle color from step 1. Note that the shading below the water line is lightly drybrushed to soften the appearance of the submerged stems.

Float tints of Cadmium Yellow + Tangelo Orange on the flower heads, especially around the center of the larger flower, using a side-loaded no. 8 flat. Add a burst of fine gray lines to each filament stem to fill out the puffball using a no. 10/0 mid-liner and the gray mixture from step 1.

To prevent paint from lifting on the bottle, allow each floated layer to dry before continuing with the next step. Using the thinned blue-green bottle mixture and a no. 4 flat, float color horizontally across the back edge of the water, under the front edge of the water, and across the curve that represents the bottom of the inside of the bottle. Let dry. Float the blue-green mixture along the right and left outside edges using a no. 10 flat.

Float a weak tint of the blue-green color under the bottle and outward to the right to create a transparent cast shadow on the table. Let dry. Lay a back-to-back float just to the inside of the right edge of the bottle, walking the color out to tint the rest of the glass. Place another narrow back-to-back float to the inside of the left edge. Let dry.

Tip of the Brush

Before transferring any symmetrical object, such as a bottle or a glass, be sure the shape of both sides is accurate. To justify outside edges, trace only one half of the object onto tracing paper. Then fold the paper over at the center and retrace on the opposite side.

4. Add the final details and highlights. Highlight top-facing petal edges on the dandelions with dry-brushed strokes of Snow (Titanium) White and the no. 1 mid-liner. Drybrush a soft veil of Snow (Titanium) White on the puffball and add several white filament line clusters to create additional depth and form. For added interest, paint a few little "parachutes" drifting down onto the table.

Place reflective highlights on the bottle with back-to-back floats of Snow (Titanium) White and the no. 10 flat. Place the strongest highlight to the left of center (along the narrow shading streak). Place a secondary highlight just to the inside of the right edge. Add sparkles of bright Snow (Titanium) White to the raised and curved planes of the glass.

Add tints of yellow and orange to the bottle and table to represent the reflective quality of the glass and to unify the colors. Add final Snow (Titanium) White highlights on top of the color tints.

A Simple Composition of a Christmas Rose With Holly

Painted on a round box, this cheerful design would make a lovely hostess gift for a Christmas tea. Masking the flowers, berries and ribbon gives you freedom to work colors into the surrounding areas without worrying about losing edges and details. Note how the red berries appear to pop out against the complementary green background leaves.

"Then heigh-ho! The holly!
This life is most jolly."
—WILLIAM SHAKESPEARE

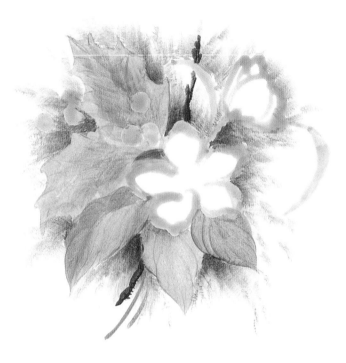

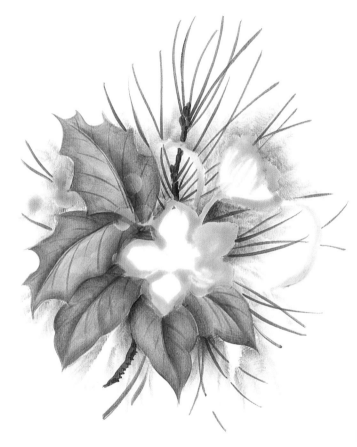

1. Place the initial colors . Carefully cover the berries, flower edges and highlighted ribbon sections with masking fluid. (See page 20.)

Base the leaves with a mixture of Cadmium Yellow + a touch of Forest Green and a no. 6 flat. A touch of Warm White may be added for better coverage.

Place the pine branch with Honey Brown and Burnt Umber double-loaded on a no. 1 mid-liner. Allow the strokes to be rough and uneven for a natural look.

Pat in the background shadows with a no. 12 flat dressed with medium mix and side loaded with thinned Evergreen. Allow the color to remain darker near the center of the bouquet and fade outward to form a soft halo around the flower petals.

2. Develop the greens. Stroke the pine needles with Forest Green and Evergreen using a no. 1 mid-liner. Place the vein details on the leaves with a no. 10/0 mid-liner.

With a no. 6 flat, separate the individual leaves and shade leaf edges and center veins with floated layers of Forest Green. Deepen underlying edges with a mixture of Forest Green + a touch of Payne's Grey. Highlight the three flower leaves with dry-brushed strokes of Warm White using a no. 2 filbert.

Remove the masking fluid (see page 20) and brush away telltale crumbs with a clean, dry paper towel.

Materials List

Brushes: nos. 4, 6 and 12 flats, nos. 2 and 6 filberts, nos. 1 and 10/0 mid-liners

DecoArt Americana Acrylics: Warm White, Cadmium Yellow, Yellow Light, Tangelo Orange, True Red, Napa Red, Forest Green, Evergreen, Payne's Grey, Burnt Umber, Honey Brown

Additional materials: medium mix (page 20), masking fluid

Pattern: see page 125

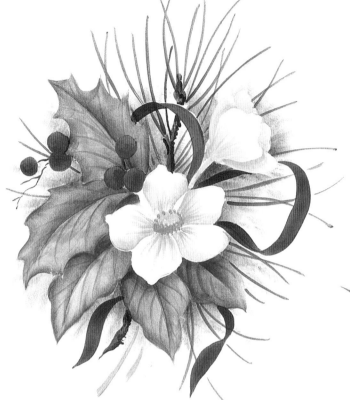

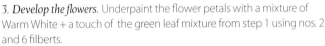

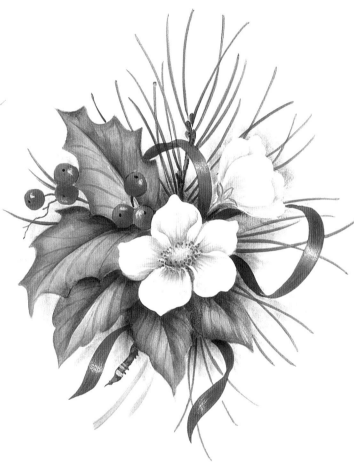

3. *Develop the flowers.* Underpaint the flower petals with a mixture of Warm White + a touch of the green leaf mixture from step 1 using nos. 2 and 6 filberts.

To separate and shade the petals, float on a thin Honey Brown wash, pulling soft lines outward from the center using the knife-edge of a no. 4 flat. Dab the flower center with Cadmium Yellow and Tangelo Orange using the point of a no. 1 mid-liner. Highlight with dots of Warm White.

Base the berries and the highlighted ribbon areas with Tangelo Orange and shade them with True Red using a no. 2 filbert. Stroke the shaded ribbon sections with Napa Red.

Tip of the Brush

- *If you are painting on a dark background, underpaint the main leaves and flowers with white before applying the first color layer.*

- *To float color, select a flat brush that is slightly larger than the area to be colored. Use clean water and/or extender medium to help the paint transition gradually from the color-loaded edge into the clean edge. Place the entire width of the brush against the surface as you apply the stroke.*

4. *Complete the final details.* Transparent color tints, final highlights and details bring your painting to life.

Deepen the leaf and background shadows with floated tints of Payne's Grey using nos. 6 and 12 flats. Deepen the shading on the berries with Napa Red and the no. 4 flat.

Tint the base of each flower petal with thinned Napa Red, and float touches of True Red around the center and on random leaf edges using the no. 6 flat. Tint the flower center with Yellow Light and brighten the leaf highlights with a mixture of Yellow Light + a touch of Forest Green.

With a no. 6 flat, apply a heavily side-loaded float of Warm White around the edge of each petal. Build up gradual layers until the petals look velvety, with the underlying shading color showing through. Finish turned petal edges with a no. 10/0 mid-liner and fresh Warm White.

Use the no. 1 mid-liner to add green pollen dots around the center and place a dot of Payne's Grey at the tip of each berry. Complete the berries and ribbon with soft, dry-brushed Warm White highlights.

A Simple Composition of Poppy Anemones

This cheerful summertime bouquet is red, white and beautiful! The simple brush-stroke technique is quick and easy, too. Why not decorate a collection of colorful table accessories to brighten your next summer garden party or picnic? Don't forget the hand-painted invitations!

*"Sweet is all the land about,
and all the flowers that blow."*
—ALFRED LORD TENNYSON

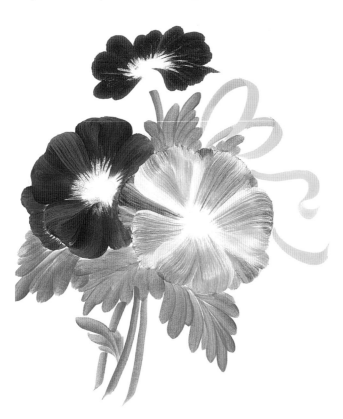

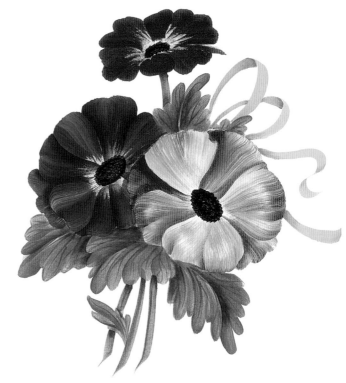

1. Place the initial colors. Place leaves and stems with a middle-value green mixture of Cadmium Yellow + Forest Green using a no. 6 filbert. Use multiple strokes that follow the contour of the leaf.

Paint the petals with a no. 10 filbert, often using two strokes to create one petal unit. For a "tipped fan" stroke, load the brush with one color and touch the tips of the brush hairs into a contrasting value of the same color. Apply heavy pressure to the brush against the surface as you fan out the bristles. Then, lift nearly straight up for a variegated petal stroke that is unfinished at the base. This takes a little practice, but the results are striking! Rinse and reload the brush between strokes to prevent over-blended colors.

Paint the red petals True Red with the brush tipped in a dark pink mixture of True Red + Snow (Titanium) White. Paint the blue petals a middle-value mixture of Blue Violet + Snow (Titanium) White with the brush tipped in Blue Violet. For the variegated pink petals, load the brush with a very light pink (Snow [Titanium] White + True Red) and tip the bristles in dark pink or red.

Stroke the ribbons with Cadmium Yellow using a no. 4 flat. Paint the shaded areas with a brush-mix of Cadmium Yellow + Honey Brown.

2. Develop the details and shadows. For best results use slightly thinned paint and carry a small amount of medium mix (page 20) in your brush. Allow the shading to dry between layers to prevent the paint from lifting.

Dab in the flower centers using the tip of the no. 4 liner and Payne's Grey.

Stroke in the leaf veins with Forest Green using a no. 10/0 mid-liner. Establish shading on the leaves and stems with floats of Forest Green. Deepen the shading with a mixture of Forest Green + Payne's Grey.

Shade and separate the petal edges with floated color using a no. 10 flat. Shade the red petals with Napa Red and the blue petals with a mixture of Blue Violet + Payne's Grey. Shade the pink petals with a thin wash of Santa Red + Napa Red.

Shade the turned ribbon edges with Honey Brown. (See page 21 for more details on shading and highlighting ribbon.)

Materials List

Brushes: nos. 6 and 10 filberts; nos. 4, 8 and 10 flats; no. 4 liner; no. 10/0 mid-liner

DecoArt Americana Acrylics: Snow (Titanium) White, Blue Violet, Payne's Grey, True Red, Napa Red, Santa Red, Cadmium Yellow, Yellow Light, Honey Brown, Forest Green

Additional materials: medium mix (page 20)

Pattern: see page 125

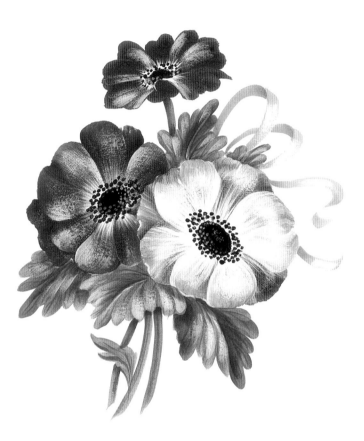

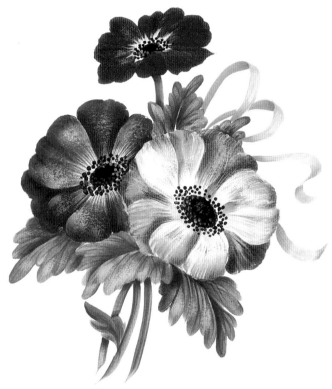

3. Add highlights and final details. Dry-brushed highlights provide a reflective support for the final layer of transparent color.

Drybrush Snow (Titanium) White highlights onto leaves, petals and ribbon using appropriately sized filbert brushes. Remember to place highlights at the center of middle values, never on shaded areas.

Pull white strokes from the flower center outward onto each petal to form a "halo" of light around the center. Several layers may be needed for brilliance.

Add pollen dots around the flower centers with Payne's Grey and the no. 4 liner. Accent pollen with a variety of colors from your palette.

Tip of the Brush

Colors that are naturally transparent, such as red and yellow, often need to be underpainted with white to keep the colors brilliant and true.

4. Add color glazes. Transparent colors illuminate the highlights and give depth to the design. Mix paint with medium mix (page 20) to create glowing color. Apply the glazes with appropriately sized flat brushes.

Glaze the leaf highlights with a yellow-green mixture of Yellow Light + a touch of Forest Green. Also brush touches of this color at the center of the pink flower.

Lightly brush the red petals with Santa Red.

Adjust the blue flower petals as desired with transparent tints of Blue Violet. Also place touches of Blue Violet in the deepest leaf shadows.

Brighten the ribbon highlights with Yellow Light.

A Simple Composition of a Single Rose

One stately rosebud is always sweet, simple and elegant. This narrow, linear motif is perfect for a memory album cover, linen place mats or a breakfast tray.

These colors work best on white or very light backgrounds. On darker backgrounds, the rose and foliage should be based with a reflective white underpainting.

"The rose has thorns only for those who would gather it."
—CHINESE PROVERB

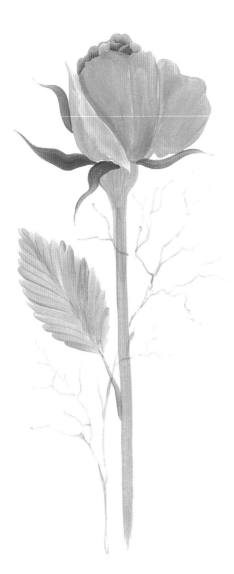

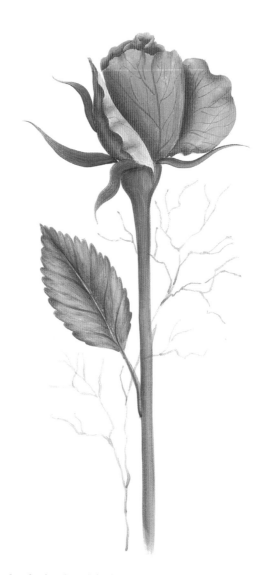

1. Place the initial colors. Create a range of pink values from light to dark by mixing Snow (Titanium) White + Santa Red.

Place individual rose petals with middle-value pinks using form-following strokes of appropriately sized filbert brushes. Use a no. 6 filbert for the small petals and a no. 10 for the larger petals. Separate the small, individual petals at the top of the bloom with darker pink shading.

Base the stem and leaf with a yellow-green mixture of Cadmium Yellow + Black Forest Green. Using a no. 6 filbert, fill the leaf with brushstrokes to suggest directional veins. Place filler branches with a no. 1 mid-liner.

Stroke in the long sepal "leaves" with a no. 1 mid-liner loaded with the yellow-green mixture and tipped with Black Forest. The stroke should have a variegated effect.

2. Develop the details and shadows. For best results, use slightly thinned paint and carry a small amount of medium mix (page 20) in your brush. Allow shading to dry between layers to prevent the paint from lifting.

Place the veins in the rose petals and leaves with a no. 1 mid-liner using form-following strokes. Use a dark-value pink for the petal veins and Black Forest Green for the leaf veins.

To shade the stem and leaf, float Black Forest Green using various sizes of flat brushes (nos. 4 and 10). Float color along both sides of the center vein, leaving a highlighted space up the middle of the leaf.

Shade and separate the rose petals with floats of dark-value pink. Note how the ruffled edges are shaded with back-to-back floats.

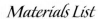

Materials List

Brushes: nos. 2, 6 and 10 filberts; nos. 4 and 10 flats; nos. 1 mid-liner

DecoArt Americana Acrylics: Snow (Titanium) White, Cadmium Yellow, Forest Green, Santa Red, Napa Red, Payne's Grey, Black Forest Green

Additional materials: medium mix (page 20)

Pattern: see page 126

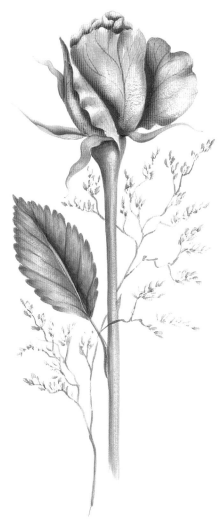

3. Strengthen the shadows and add filler. Use Napa Red—a cool, transparent red hue—for the final shadows on the rose petals. Vary the shadow shapes by exerting and releasing pressure on the flat brush when floating on the color. (Use a no. 4 or no. 10 flat depending on the petal size.)

Strengthen the leaf and stem shadows with a mixture of Black Forest Green + a touch of Payne's Grey. Float color only on one side of the central leaf vein and along the left edge of the stem as shown. Add touches of dark green here and there to the filler branches, carrying one or two branches over the rose stem to create perspective.

Dab the filler buds with a mixture of Snow (Titanium) White + a touch of Payne's Grey using the knife-edge of a no. 2 filbert.

Tip of the Brush

Keep filler foliage light and airy, allowing your main flower to be the star of the show.

4. Add color glazes and final highlights. Dry-brushed highlights on the leaf provide a reflective support for the final layer of transparent color. Remember to place highlights at the center of middle values, never on shaded areas.

Using appropriately sized filbert brushes, gradually drybrush Snow (Titanium) White highlights on the rose petals to give them a soft, velvety texture. Note the shape and placement of the highlight on each petal.

Highlight the stems, sepals and the leaf with dry-brushed Snow (Titanium) White using form-following strokes and filbert brushes.

Over the stem and leaf highlights, brush a warm yellow-green glaze mixture of Cadmium Yellow + a touch of Black Forest Green.

Add white buds to the filler foliage to highlight and give dimension.

A Simple Composition of Pansies

I love pansies! Their sweet, happy faces are a symbol of tender thoughts and love. Bless someone special with this charming, petite bouquet.

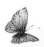

"No tears dim the sweet look that nature wears."

—HENRY WADSWORTH LONGFELLOW

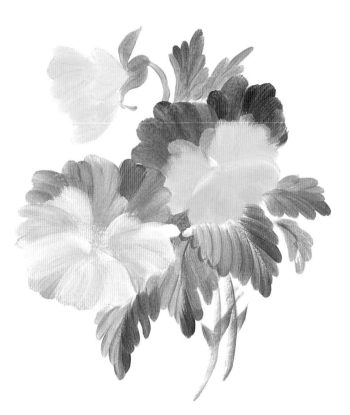

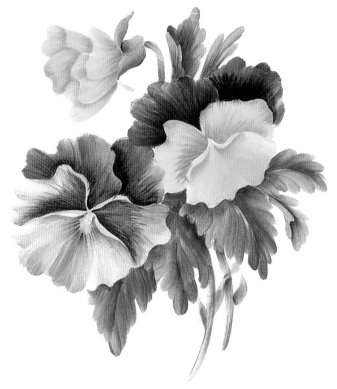

1. Place the initial colors. The main design elements are placed with local colors to establish overall patterns of color. Use brush sizes that are appropriate to the size of the area being painted.

Fill in leaves with no. 6 filbert brushstrokes. Place the stems with a no. 4 liner. Use Olive Green on the highlighted areas and a mixture of Olive Green + Forest Green on the shaded areas.

Base the petals with contour-following strokes using a no. 10 filbert. Begin by painting the darker back petals, and make the side and front petals increasingly lighter in value. Here, I've used Snow (Titanium) White with Dioxazine Purple for the purple petals and Cadmium Yellow + a touch of Snow (Titanium) White for the yellow petals. Paint the pale violet pansy with a mixture of Napa Red + a touch of Dioxazine Purple combined with varying amounts of Snow (Titanium) White to achieve different values.

2. Develop the initial shadows and details. For best results, use slightly thinned paint and carry a small amount of medium mix (page 20) in your brush. Float color with the width of a flat brush, and then pull the color outward using the knife-edge.

Stroke veins on the leaves with a no. 10/0 mid-liner and Forest Green. Float Forest Green along the center veins of the large leaves with a no. 8 flat. Separate individual leaves and create cast shadows with a mixture of Forest Green + Black Forest Green.

Shade the purple petals with Dioxazine Purple and yellow petals with a dark yellow mixture of Cadmium Yellow + Honey Brown. Use the Napa Red + Dioxazine Purple mixture from step 1 to begin shading the light violet flower. Leave some white space at the flower centers where the front petals are joined.

Materials List

Brushes: nos. 4 and 8 flats; nos. 6, 8 and 10 filberts; no. 4 liner; no. 10/0 mid-liner

DecoArt Americana Acrylics: Snow (Titanium) White, Cadmium Yellow, Yellow Light, Honey Brown, Olive Green, Forest Green, Black Forest Green, Napa Red, Dioxazine Purple

Additional materials: medium mix (page 20)

Pattern: see page 126

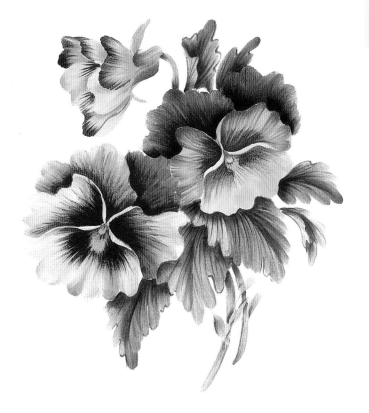

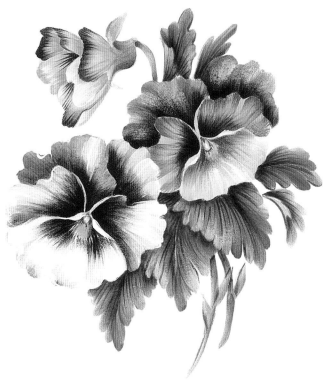

3. Strengthen the shadows and details. Push back the deepest leaf and stem shadows with floated Black Forest Green. Tone the green with a touch of Dioxazine Purple if the green alone seems too bright.

Deepen the purple and violet shadows. Note the color placement on the face of the light violet pansy. Apply the color with a side-loaded no. 8 flat and use the knife-edge of the brush to pull radiating lines outward to create the pansy face. Leave the flipped petal edges unshaded.

Shade and detail the yellow petals with several color mixtures using the same floating technique described above. Begin coloring with a mixture of Cadmium Yellow + Napa Red. Add floats of Honey Brown and add a touch of Napa Red to create variety. Remember to let the paint dry between applications of color to prevent the paint from lifting. Place the darkest shading color on the two side petals. Edge several of the folded bud petals with Dioxazine Purple or a red-violet mixture of Napa Red + Dioxazine Purple.

Place the flower centers with Cadmium Yellow. Detail with Honey Brown and Napa Red.

4. Add the final highlights and color glazes. Dry-brushed highlights on leaves provide a reflective support for the final layer of transparent color. Remember to place highlights at the center of middle values, never on shaded areas.

Drybrush Snow (Titanium) White accents on the yellow and purple pansy petals and on the highlighted edges of leaves with a no. 8 filbert.

Build up several layers of dry-brushed Snow (Titanium) White to lighten the front three petals of the light violet pansy using the no. 8 filbert. Lightly outline ruffled and flipped edges with undiluted Snow (Titanium) White and a no. 10/0 mid-liner.

With appropriately sized filbert brushes, brighten the yellow petals with kisses (light, delicate touches) of Yellow Light mixed with medium mix. Glaze the leaf and stem highlights with a mixture of Yellow Light + a touch of Black Forest Green. Accent the "eye patches" on the two side petals of both flowers with Dioxazine Purple.

Tip of the Brush

When planning your color arrangement, use colored pencils to explore the possibilities.

A Simple Composition of Field Flowers and Brushes

Field flowers and native grasses make a fresh, airy bouquet. The paintbrushes help tell a story about the composition and add weight and balance to the design.

"And the earth brought forth grass, and herb yielding seed after his kind…"

—GENESIS 1:12 KJV

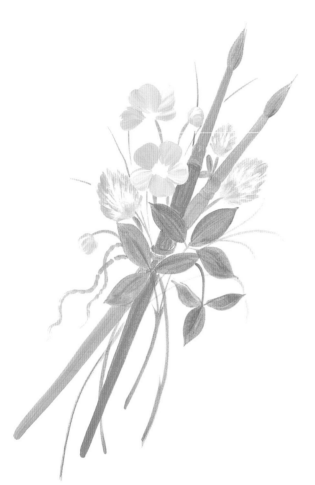

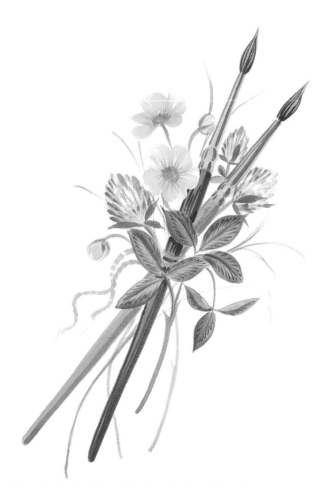

1. Place the main design elements. Carefully transfer the main elements of the design to your prepared surface using a ruler for the straight edges of the brushes. When painting the brushes, be sure to fill in all the little spaces between the stems, leaves and twine.

Establish a framework of stems and grasses with thinned Olive Green and Honey Brown using nos. 4 and 1 liners. Base the clover leaves with Olive Green using a no. 4 filbert.

Stroke in the buttercup petals and buds with a no. 6 filbert loaded with Cadmium Yellow and tipped in Warm White. Brush the clover heads with Warm White and then overstroke them with a pink mixture of Warm White + a touch of True Red using the knife-edge of a no. 4 filbert.

With the no. 4 liner, fill in the back brush handle, both brush tips and the twine ribbon with a mixture of Cadmium Yellow + Honey Brown. Fill in the front brush handle with a light blue mixture of Warm White + Blue Violet. Base the ferrules with a silver-gray mixture of Warm White + a touch of Payne's Grey using the no. 4 liner.

2. Develop the details and shadows. Shade and detail the green leaves and stems with Forest Green. Use a 10/0 mid-liner for the stems and small leaves and a no. 4 flat to float shading along the leaf edges and center veins. Use the knife-edge of a no. 4 filbert for the overstroked details on the clover leaves.

Shade and detail the buttercup petals with the Cadmium Yellow + Honey Brown mixture from step 1 and the no. 4 flat. Tap in the centers with an orange mixture using Cadmium Yellow + a touch of True Red and the no. 4 liner.

With the knife-edge of a no. 4 filbert, overstroke the clover heads only along the outside edges with a deep pink mixture using True Red + Warm White. Add a touch of thinned Olive Green at the base of each clover head with the no. 4 liner.

Shade the brushes along the edges with long, straight lines of color applied with a no. 4 liner dressed with medium mix. Shade the yellow brush with Honey Brown and the blue brush with a darker blue. Use a dark blue-gray mixture of Warm White + Payne's Grey to shade the ferrules. Add detail lines to the brush hairs with Burnt Umber using a no. 10/0 mid-liner.

Materials List

Brushes: nos. 4 and 12 flats; nos. 4 and 6 filberts; no. 1 and 4 liners; no. 10/0 mid-liner; old, scruffy filbert for stippling

DecoArt Americana Acrylics: Warm White, Yellow Light, Cadmium Yellow, Honey Brown, Olive Green, Forest Green, True Red, Blue Violet, Burnt Umber, Payne's Grey

Additional materials: medium mix (page 20), ruler

Pattern: see page 126

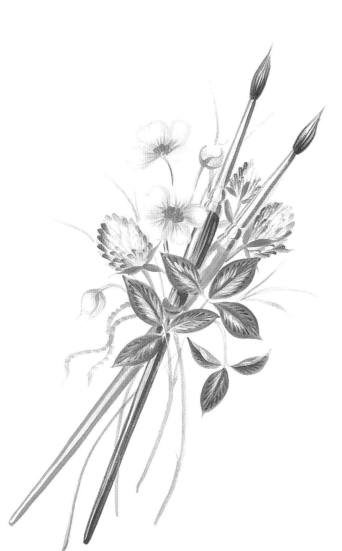

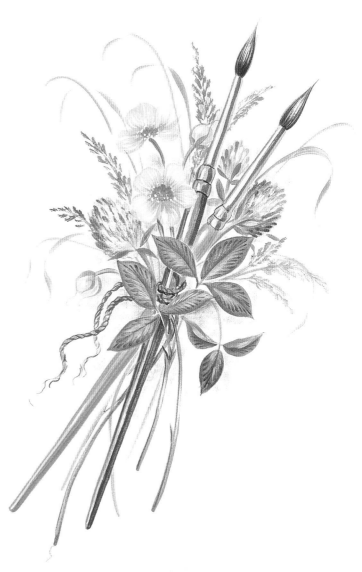

3. Place the highlights. Drybrush soft Warm White highlights on the flowers and leaves using a no. 4 filbert. Highlight the shiny brush surfaces with defined lines of Warm White created with a no. 4 liner. Use fresh, undiluted paint to build sparkling highlights.

4. Add color glazes and final details. Thin your colors with medium mix (page 20) to create transparent glazes.

Place filler grasses with 'thin-thick-thin' brushstrokes of a no. 4 liner using mixtures of Warm White and Honey Brown. Stipple the flowering grass head with the tip of a scruffy filbert using Honey Brown + pink mixture.

Warm the clover leaves with Yellow Light + a touch of Forest Green on a no. 4 filbert. Detail the stems with Forest Green using a no. 10/0 mid-liner.

Brighten the buttercups and the handle of the yellow brush with Yellow Light and the no. 4 filbert. Add tiny white pollen dots around the flower centers with the no. 10/0 mid-liner.

Detail the jute twine tie with fine Burnt Umber lines using the no. 10/0 mid-liner.

Finally, pat in some soft blue sky in the background to balance the blue of the brush handle. Thin the light blue mixture from step 1 and use a side-loaded no. 12 flat to achieve this effect.

Tip of the Brush

- *When transferring a pattern, keep your lines faint and brief, eliminating any unnecessary details. Gently remove all telltale transfer lines as soon as the initial colors have been laid in.*

- *One way to achieve perspective in a composition is to overlap several design elements.*

A Simple Composition of Daisies and Bachelor's Buttons

A cheerful arrangement of daisies and bachelor's buttons says, "Sunshine fresh!" In the completed painting, I extended the design by flipping the pattern and repeating it end-to-end to create a border motif.

Materials List

Brushes: nos. 2 and 4 flats; nos. 4 and 10 filberts; no. 4 liner; no. 10/0 mid-liner; old, scruffy filbert

DecoArt Americana Acrylics: Snow (Titanium) White, Cadmium Yellow, Tangelo Orange, Olive Green, Evergreen, Honey Brown, Blue Violet, Payne's Grey

Additional materials: medium mix (page 20)

Pattern: see page 125

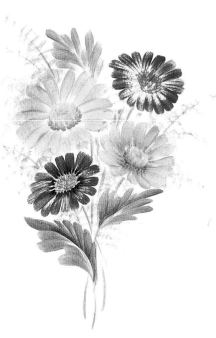

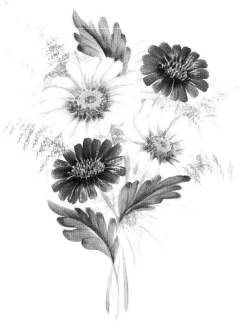

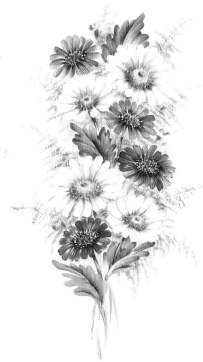

1. Place the initial colors, textures and shadows. Stroke a light framework of stems for the flowers, leaves and ferns using a no. 4 liner and Olive Green. Use a no. 4 filbert loaded with Olive Green to place the leaf and daisy petal strokes. Float Evergreen along the center veins of leaves.

Tap the daisy centers with Cadmium Yellow on a no. 4 liner. Shade with textured dabs of Honey Brown. Float shading on the daisy petals around the center with a thinned mixture of Evergreen + Blue Violet and a no. 10 filbert.

Place the bachelor's button petals with mixtures of Snow (Titanium) White + Blue Violet with a no. 2 flat. Tap in the flower centers with a light blue value using the knife-edge of the no. 2 flat. Float shading on the bachelor's button petals around the center with Blue Violet.

Pat on the fern filler with thinned Olive Green using the rounded tip of a no. 10 filbert. A slightly worn scruffy brush is ideal for this step. Experiment on a separate piece of paper until you get the right effect.

2. Develop the details and strengthen shadows. When floating shadows, use slightly thinned paint and carry a small amount of medium mix (page 20) in your brush.

Accent the contoured edges of the leaves with floats of Evergreen on the no. 4 flat. Leave some unshaded areas as highlights.

Overstroke the daisy petals with undiluted Snow (Titanium) White using a no. 4 liner. Allow some of the underlying color to show through. Accent the daisy centers with touches of Tangelo Orange.

Strengthen the floated Blue Violet shading on the bachelor's buttons. Tap these centers with contrasting light and dark blue values double loaded on the knife-edge of a no. 2 flat. Add tints of Blue Violet at the base of the daisy petals also.

Gradually build up texture on the ferns with additional values of green using the no. 10 filbert.

3. Add the final tints, details and highlights. A ring of tiny white pollen dots encircles the bachelor's buttons' centers. Detail the daisy centers with dots of yellow, orange and white.

Outline and detail the front-facing blue petals using a no. 10/0 mid-liner and Blue Violet. A few short, sketchy lines will be enough to give the petals their characteristic "shaggy" appearance. Scatter small blue buds throughout the arrangement for added interest and variety.

Pat cool tints on the background foliage behind the flowers and leaves. Here, I used my scruffy filbert dressed with medium mix and side loaded with thinned Blue Violet to add contrast behind the daisy petals.

Add final highlights to the daisy petals using a no. 2 filbert tipped with undiluted Snow (Titanium) White. Front-facing and top-lying petals should receive the brightest textured highlights.

A Simple Composition of Fall Leaves and Acorns

This colorful collection of autumn leaves features a *grisaille* technique developed with earthtones and then glazed with analogous hues.

Materials List

Brushes: nos. 6, 8 and 12 flats; nos. 4 and 10 filberts; no. 1 mid-liner

DecoArt Americana Acrylics: Warm White, Yellow Light, Honey Brown, Burnt Umber, Tangelo Orange, Santa Red, Forest Green

Additional materials: medium mix (page 20)

Pattern: see page 124

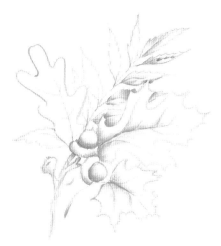

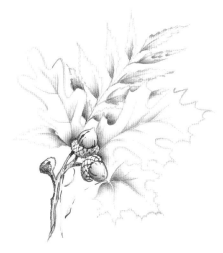

1. Outline and shade the forms. Loosely outline the leaves, acorns and branches using thinned Honey Brown and a no. 1 mid-liner.

Float the first shading value, Honey Brown, using a side-loaded no. 8 flat.

2. Develop the details and deepen shading. Develop details and texture lines on branches and acorns with the no. 1 mid-liner and Burnt Umber.

Strengthen the deepest shadows on underlying edges with floated Burnt Umber and the no. 8 flat.

Tip of the Brush

- *A large filbert brush is ideal for applying color glazes.*

- *Apply the lightest and warmest glazing colors first, followed by progressively darker, cooler hues. Allow ample drying time between layers to prevent colors from lifting.*

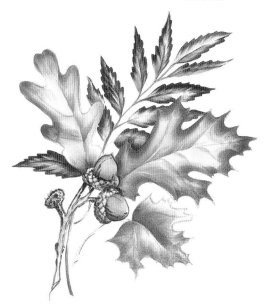

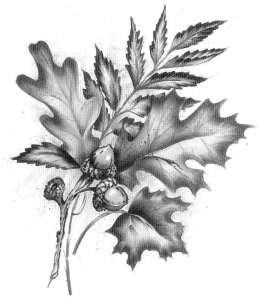

3. Place the first glazing layers. Wash and float transparent glazes of Yellow Light, Tangelo Orange and Santa Red over the design elements. Thin the colors with medium mix (page 20), and carry a little medium in your brush as you paint. A no. 10 filbert is ideal for applying color glazes.

Begin with an overall wash of yellow on the major leaves and acorns, and float orange here and there along the edges.

Float the edges of the red leaves with a mixture of Santa Red + Honey Brown.

4. Add the final glazing, details and highlights. Strengthen the leaf colors with additional floated layers of yellow, orange and red.

Add touches of yellow and green on the acorns and on several leaves for balance.

Add final details to the leaves with Burnt Umber to create torn edges and "bug bites." Drybrush touches of Warm White onto the acorns for added dimension.

Pat on background filler with layers of thinned Honey Brown, yellow and green and Tangelo Orange using a side-loaded no. 12 flat.

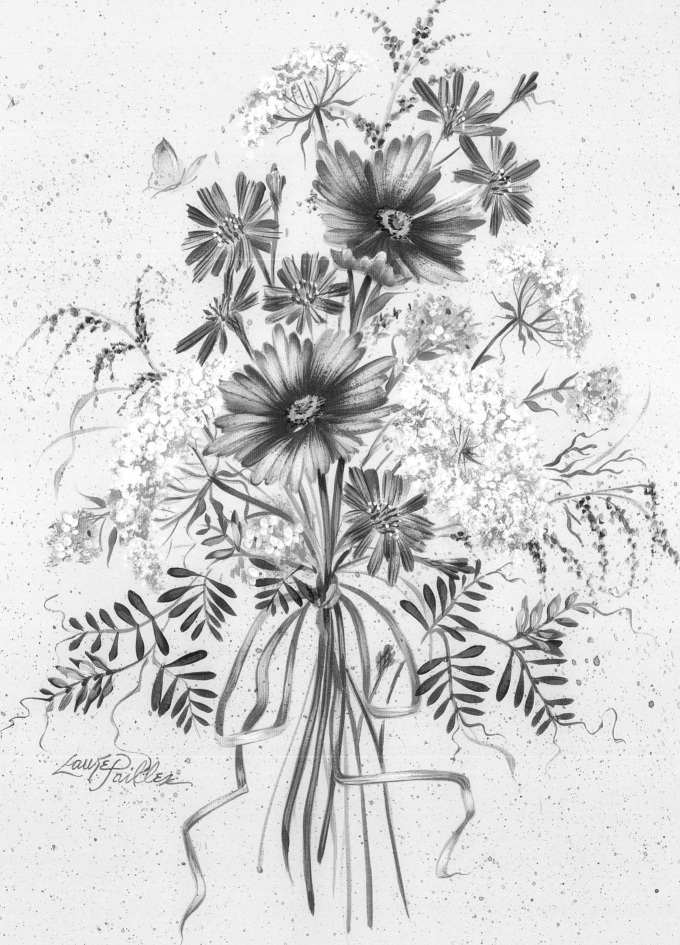

Country Roads

Let's gather a rainbow of wildflowers! Pink cosmos, blue chicories, yellow herb flowers and creamy white Queen Anne's lace are bound with graceful grasses for a naturalized bouquet. These elements are simple enough to paint freehand on a small item such as a breakfast tray, or even on larger pieces such as a chair or dresser.

"And the earth brought forth grass, and herb yielding seed after his kind…"

—GENESIS 1:12 KJV

PALETTE: DECOART AMERICANA ACRYLICS

Snow (Titanium) White

Cadmium Yellow

Honey Brown

Olive Green

Forest Green

Santa Red

Blue Violet

Burnt Sienna

BACKGROUND COLOR

Blue Chiffon

Materials List

Brushes: nos. 2, 8, and 10 flats; no. 4 liner; nos. 10/0 and 1 mid-liners; ¼-inch (6mm) angular bristle; no. 4 round

Additional materials: DecoArt Easy Float; DecoArt Faux Glazing Medium; toothbrush or large, stiff brush for spattering

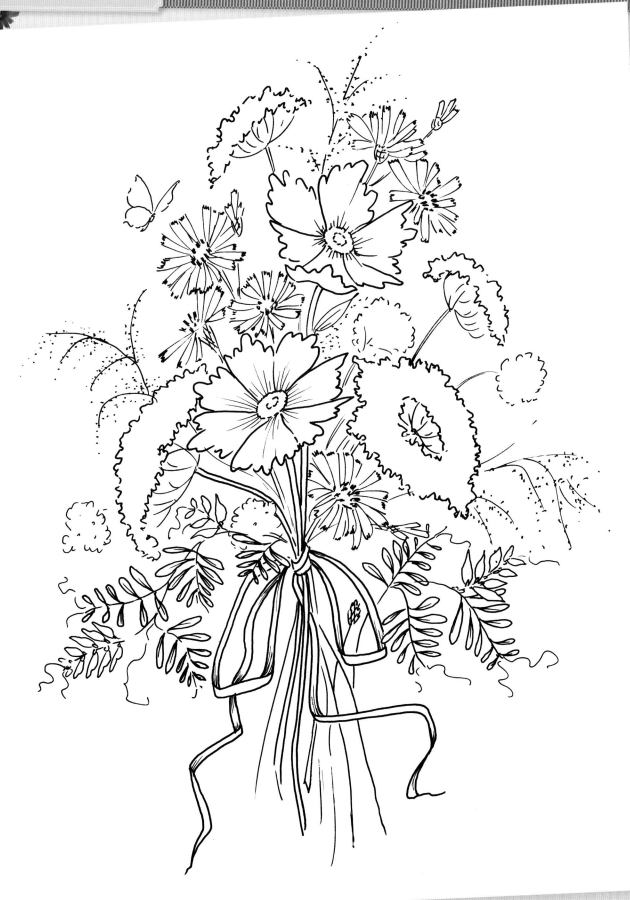

This pattern may be hand-traced or photocopied for personal use only.
Enlarge at 111% on a photocopier to bring it up to full size.

Before you paint. Paint the background Blue Chiffon. Trace and transfer the pattern.

1. Establish main stems. Dress a no. 4 liner with Olive Green and add some Forest Green to one side of the brush. Using the point of the brush, establish the main stems. Fill in the background framework. Add Honey Brown for the grassy stems.

2. Establish chicory stems. Still using the no. 4 liner, establish the chicory stems by brush mixing equal amounts of Forest Green, Blue Violet and Snow (Titanium) White.

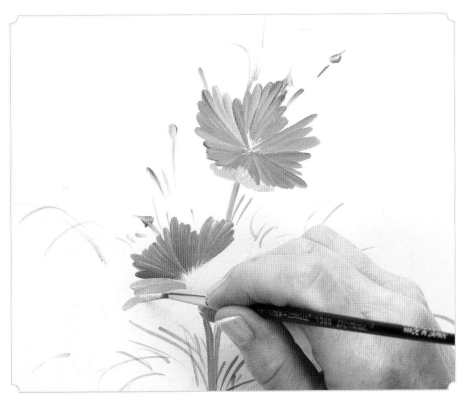

3. Place the main flower petals. For the cosmos, dress a no. 4 liner with Snow (Titanium) White, and then pick up some Santa Red to make a variety of pinks. Establish each petal with a series of strokes. Pull the strokes from the outer edge of the petal toward the center.

Tip of the Brush

Brush mixing allows you to create a variety of colors, making it is easier to separate the petals of each flower. When using brush-mixes, no two colors are alike; some are light and some are dark.

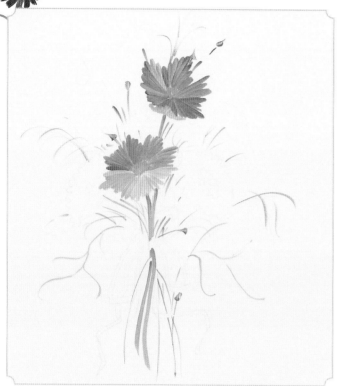

4. *Place the main flowers*. Tap in the centers of the cosmos with Olive Green using the point of the no. 4 liner.

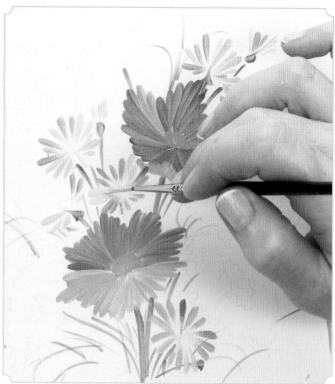

5. *Place the chicory petals*. Using a no. 4 liner, paint the chicory petals by picking up some Snow (Titanium) White and adding a small amount of Blue Violet so the color is very pale. Flatten the brush to create a square edge, and pull the petals from the outer edge inward (see page 21).

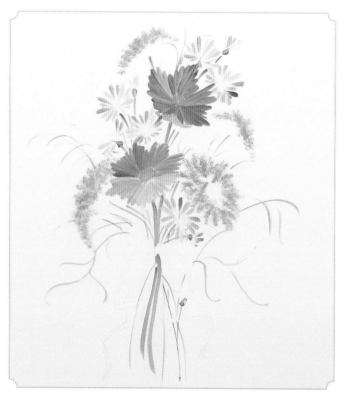

6. *Place the main flower petals.* Stipple on the Queen Anne's lace using a ¼-inch (6mm) angular bristle brush and a brush-mix of equal parts Olive Green and Forest Green. The stippling should follow the drape of the flower and the direction the flower form is taking.

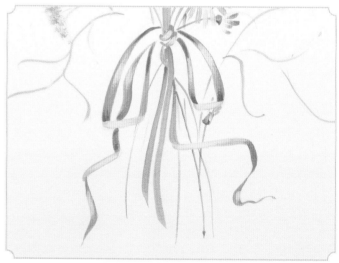

7. *Add the raffia ribbon*. Place the raffia ribbon with a no. 4 liner and a brush-mix of Honey Brown + Snow (Titanium) White. When adding highlights and shading, remember that as objects go back, they are duller. As they come forward, they catch more light (see page 21).

Tip of the Brush

Acrylic paints dry two or three values darker than they appear to be when wet. Before you highlight or shade, allow the paint to dry and cure so you can determine the correct contrast.

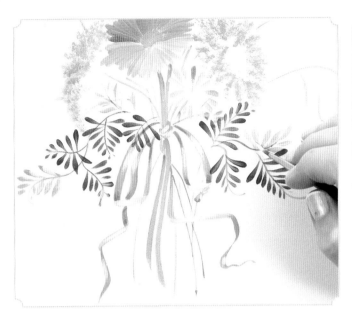

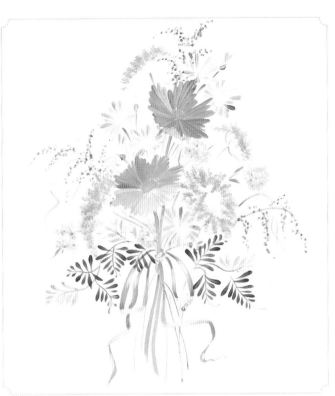

8. *Add the purple vetch.* With a no. 4 liner, place the leaves of the purple vetch using Forest Green. Pull the leaves toward the stems in a straight comma stroke. Paint the flowers in the same manner using Snow (Titanium) White + Blue Violet + a touch of Santa Red.

9. *Paint the filler grasses.* Stipple the wild mustard with a ¼-inch (6mm) angular bristle and Olive Green. Use a no. 1 mid-liner to detail the wild mustard with tiny petals of Cadmium Yellow + Snow (Titanium) White. Add sparse dots of Honey Brown for the centers. Add more Snow (Titanium) White for highlights as the color dries. Dab on the field grass with the point of a no. 4 round dressed with Honey Brown + Burnt Sienna. (The round brush gives you more paint to work with.) Using very thin paint, thinned with water and a touch of medium mix (see page 20), make grass strokes. The grass should appear thin and transparent so it does not overwhelm the bouquet.

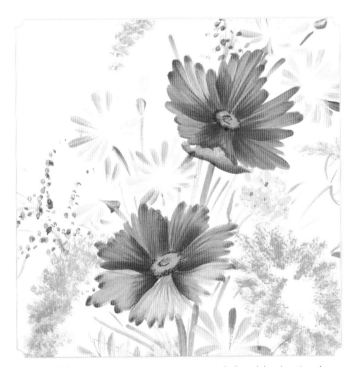

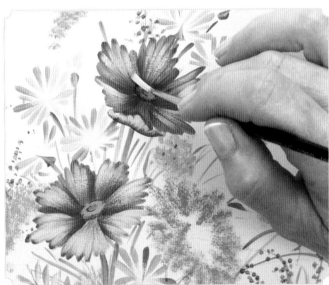

10. *Detail the cosmos.* For the cosmos, create a dark pink by dressing the no. 4 liner in Santa Red and adding a touch of Snow (Titanium) White. With this mixture, use short, wispy strokes to darken the centers of the petals. Pull the strokes from the center of the flower toward the outer edge of the petal. Side load a no. 8 flat with Santa Red to separate individual petals.

Tap in the centers with Cadmium Yellow and a no. 4 liner. Some of the green base will show through. Shade first with Honey Brown along the edge of the center. Clean the brush and follow with Burnt Sienna. Touch up with small dots of Snow (Titanium) White on a no. 1 mid-liner.

11. *Complete the cosmos.* Finish the cosmos by drybrushing overstrokes of your lightest value pink (Snow [Titanium] White + a touch of Santa Red). Pull the strokes inward from the edges of the petals. As the petals dry, you may need to add several light layers to create contrast and brighten the highlights on the forward petals.

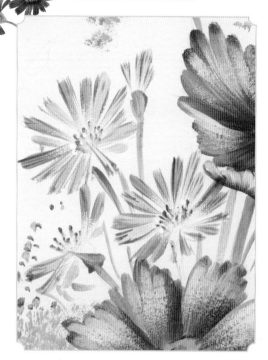

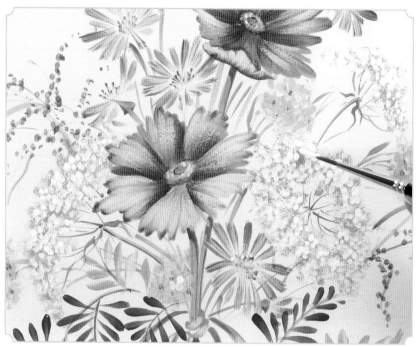

12. Complete the chicory. To finish the chicory, use a no. 10/0 mid-liner dressed with medium mix and Blue Violet. Pull vein lines in from the outer edge of each petal to create a square, shaggy appearance. Stipple the centers with a no. 2 flat double loaded with Snow (Titanium) White and Blue Violet. Then add small dots of Snow (Titanium) White with a no. 10/0 mid-liner.

13. Finish the Queen Anne's lace. For the Queen Anne's lace, lay on a light field of Snow (Titanium) White by stippling with a ¼-inch (6mm) angular bristle. Place the fine stem framework that connects the petals to the main stem with a no. 10/0 mid-liner and a mixture of Olive Green + Forest Green. Add some new growth stems and tendrils surrounding the Queen Anne's lace. Add textured petal clusters with the point of a no. 1 mid-liner loaded with very thick Snow (Titanium) White. Add cast shadows to all the main stems using a clean no. 1 mid-liner and Forest Green.

14. Paint the butterfly. Using a no. 2 flat, place the butterfly with Snow (Titanium) White; detail with a no. 10/0 mid-liner and Honey Brown. When dry, tint with a glaze of yellow and blush the wing tip with an orange made from a brush-mix of Cadmium Yellow + Santa Red.

15. Add some glazes. Dress a no. 10 flat with medium mix and thin out a small amount of Santa Red to a very weak, translucent consistency. Add soft tints of red glaze here and there to the Queen Anne's lace. Keep the glaze to the undersides and to the areas that would be naturally shadowed. Add a little glaze to the chicory and wild mustard to reflect the pink color from the cosmos. Use the corner of the brush to add glaze to the field grass. Unity is important in this composition, and glazing unifies the colors in the painting by spreading out the pink color from the center.

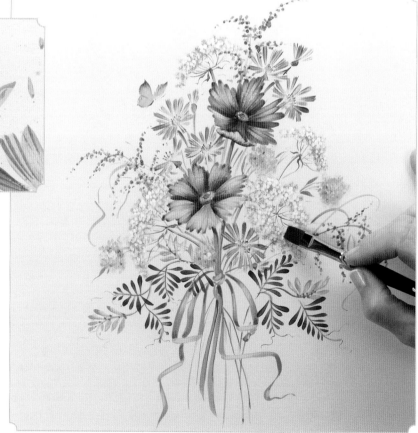

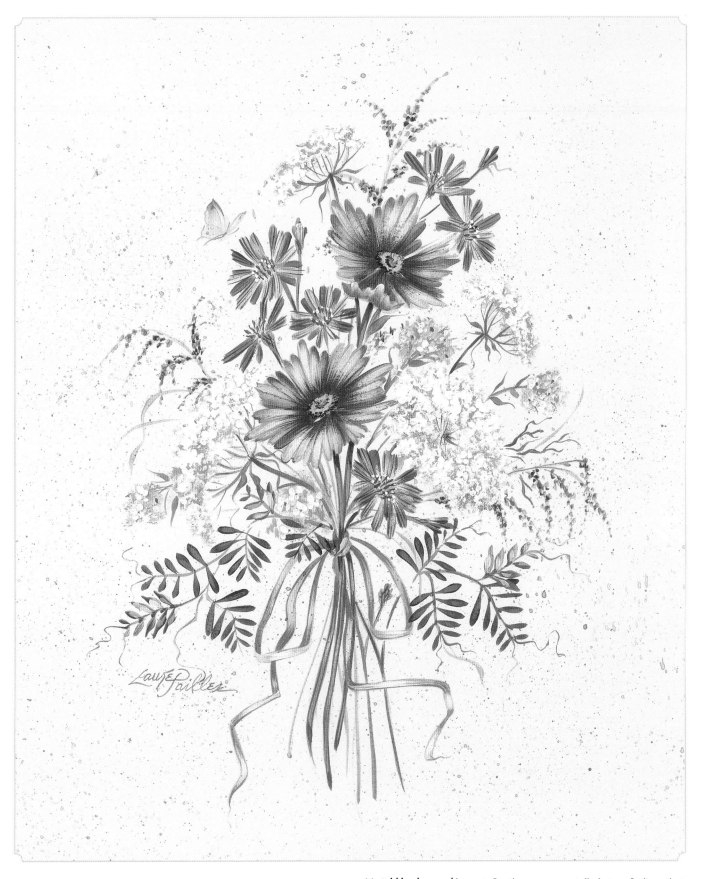

16. Add background interest. Gently remove any telltale transfer lines that may still exist. Fleck the background with alternate spatters of color using Forest Green, Blue Violet and Santa Red (see page 21).

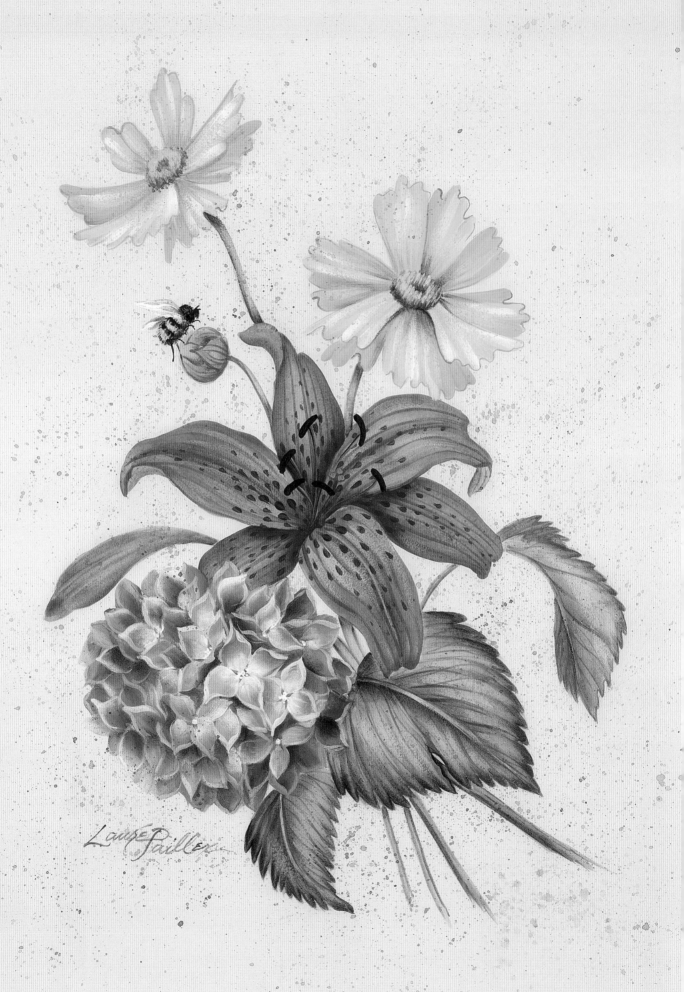

Backyard Beauties

A treasure may be waiting outside your back door! These three late bloomers were collected from my garden in August. The complementary orange-and-blue color harmony as well as the variety of shapes and textures give this simple arrangement its strong appeal.

"How doth the little busy bee improve each shining hour, And gather honey all the day from every opening flower!"

—ROBERT LOUIS STEVENSON

PALETTE: DECOART AMERICANA ACRYLICS

Warm White

Cadmium Yellow

Yellow Light

Tangelo Orange

Napa Red

Blue Violet

Evergreen

Black Forest Green

Olive Green

Honey Brown

Burnt Sienna

BACKGROUND COLOR

Hi-Lite Flesh

Materials List

Brushes: nos. 4, 8 and 10 flats; no. 4 liner; nos. 2, 4, 8 and 10 filberts; nos. 10/0 and 1 mid-liners

Additional materials: DecoArt Easy Float; DecoArt Faux Glazing Medium; toothbrush or large, stiff brush for spattering

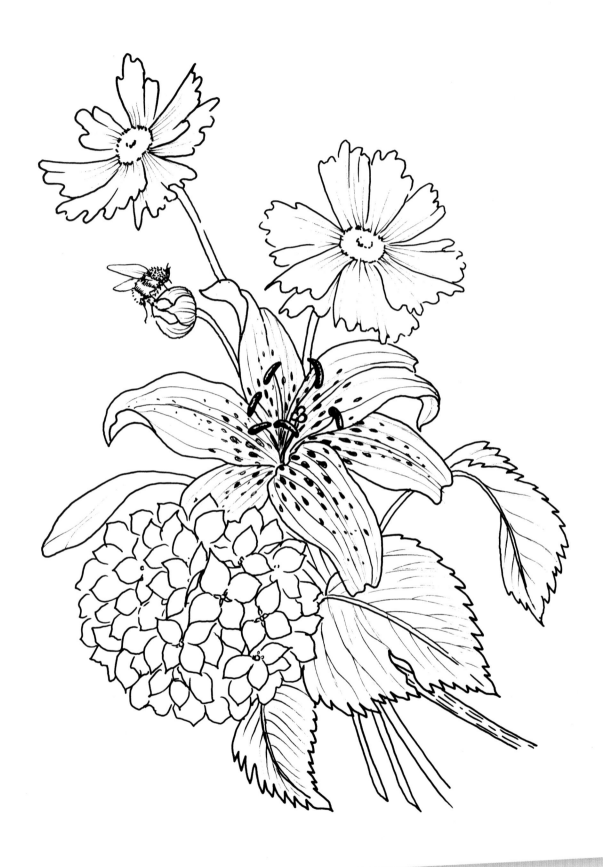

This pattern may be hand-traced or photocopied for personal use only.
Enlarge at 111% on a photocopier to bring it up to full size.

Before you paint. Basecoat your surface with Hi-Lite Flesh. Trace and transfer the pattern.

2. Detail the leaves. Place the veins with a no. 1 mid-liner and Evergreen thinned with medium mix (see page 20). Note: The center vein is drawn with a double line. Shade on the outside of each line. The vein lines follow the brushstrokes established in step 1. Outline the edges of the leaves and the tear in the front leaf. Shade the stems with Evergreen. Dress a no. 10 flat with medium mix and side load it with a mixture of Olive Green + Evergreen to shade along the center veins and under the flowers. Let dry, and then shade along the edges.

3. Shade the leaves. Float straight Evergreen in the deepest shadows where the leaves recede beneath the flowers, still using the no. 10 flat dressed with medium mix.

1. Place the initial colors. Place the stems using the no. 4 liner. For the coreopsis stems, load the brush with Olive Green and cut a small amount of Evergreen onto one side of the brush. Place the hydrangea and tiger lily stems using Olive Green + Honey Brown. Base the leaves with a series of form-following strokes using Olive Green and a no. 8 flat.

Paint the coreopsis with a no. 4 liner and a brush-mix of Cadmium Yellow + Warm White. Vary the colors on your brush for each petal to separate the petals. Pick up more Warm White at some times and more Cadmium Yellow at other times. Tap in the centers with Olive Green and a no. 4 liner.

Fill in the bee with a mixture of Cadmium Yellow and Warm White. Paint the hydrangea with a no. 10 filbert and a brush-mix of Blue Violet + Warm White. Work from the edges toward the center, letting the color fade toward the center.

Still using the no. 10 filbert, develop the tiger lily with a yellow-orange brush-mix of Cadmium Yellow and Tangelo Orange double loaded with straight Tangelo Orange. Keep the Tangelo Orange toward the outside edges for the back petals. For the top-facing petals, keep the yellow-orange mixture on the outside. Place the turned or flipped edges of the petals with yellow-orange using a no. 4 filbert.

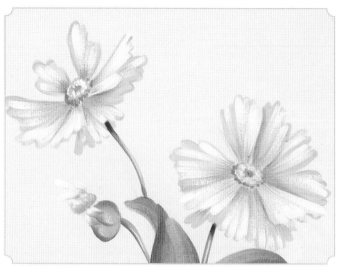

4. Highlight the leaves. With a no. 4 filbert, drybrush the highlights on the leaves with Warm White + a touch of Olive Green. The highlights strike the high points on the leaves, between the veins, and follow the contour of the leaves. Add highlights to the coreopsis bud and stems as well.

5. Detail the coreopsis. With a no. 4 liner dressed with medium mix, shade and detail the coreopsis with a brush-mix of Cadmium Yellow and Honey Brown pulled from the base of the flower outward with short strokes. Separate the petals with this mixture. With a no. 8 flat, float the Honey Brown to further separate the petals.

Drybrush highlights of Warm White overstrokes with a no. 4 liner. Start at the outer edge of the petal and stroke inward, concentrating on the top-lying petals. Stipple the center with the point of the no. 4 liner dressed with Cadmium Yellow. Shade with Honey Brown. Highlight with dabs of Warm White.

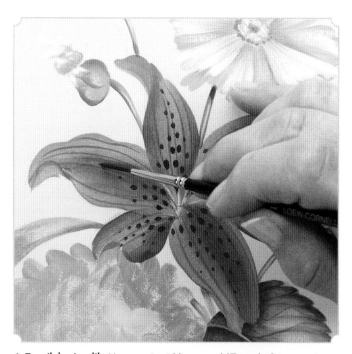

6. Detail the tiger lily. Use a no. 1 mid-liner to add Tangelo Orange veins to the tiger lily petals. The veins radiate from the center of the flower to the tip of the petal in parallel lines. Use the point of the no. 1 mid-liner and Burnt Sienna to place the spots. As with the veins, start at the base and work outward.

7. Shade the tiger lily. Separate the back petals from the front petals by floating a mixture of Tangelo Orange and Burnt Sienna loaded on the corner of a no. 10 flat brush. Add shading to the bottom side of the bud. Deepen shading in the throat with straight Burnt Sienna.

Tip of the Brush

Execute each stroke following the contour of the object, carrying the stroke through in a smooth, continuous motion.

9. *Add the lily's pistil.* Use a no. 10/0 mid-liner to paint the pistil and filaments with Olive Green. With the same brush, paint the anthers with a mixture of Burnt Sienna + a purple made from Blue Violet and Napa Red.

8. *Highlight the tiger lily.* With a no. 2 filbert, drybrush the highlights using Warm White. Concentrate on the light edges of the front petals and where the petals would bend.

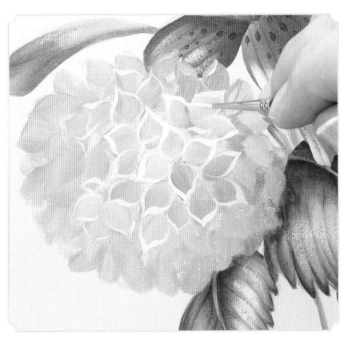

11. *Shade the hydrangea petals.* Float straight Blue Violet with a no. 8 flat to shade and separate the individual florets. Apply the sharpest shading details near the center of the sphere.

10. *Add petals to the hydrangea.* For the hydrangea, use a no. 8 filbert and various brush-mixes of Warm White and Blue Violet in light and middle values. Outline the petals with a no. 10/0 mid-liner and a very light blue made from Warm White and a touch of Blue Violet. Begin the definition with the floret in the center and build outward from there.

Tip of the Brush

For "floated color," select a flat brush that is slightly larger than the area to be colored. Use clean water and/or extender medium to help the paint transition gradually from color-loaded edge into the clean edge. Place the entire width of the brush against the surface as you apply the stroke.

13. Detail the hydrangea petals. Tint the highlighted centers with a float of very thin Olive Green on a no. 4 flat. With a no. 10/0 mid-liner, mix Evergreen and Olive Green and separate the center petals. Add pollen dots in the center with Warm White loaded on a clean no. 10/0 mid-liner.

12. Highlight the hydrangea petals. Using a no. 4 flat, float Warm White at the base of the florets for highlights. Start in the center of the sphere and work outward. The center flowers may need two coats to pull out more of the white highlight. Be sparse with the highlights at the edges and near the back.

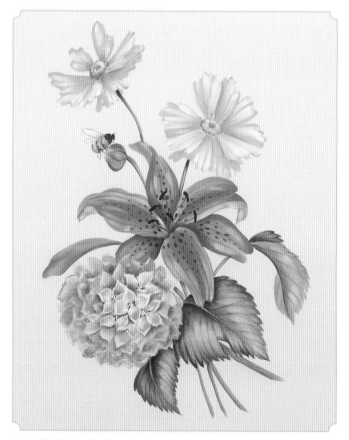

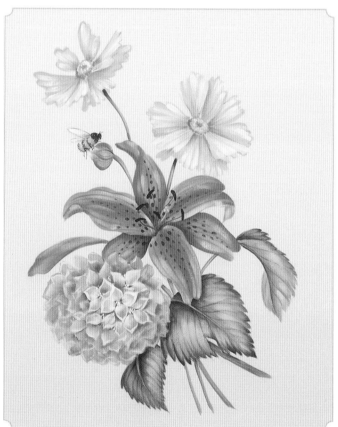

15. Add orange color glaze. Dress a no. 10 flat with medium mix and side load with Tangelo Orange. Glaze the shadows on the coreopsis and shade the turned edges of the tiger lily. Also tint random leaf edges and the stems with this glaze. With a clean no. 10 flat, glaze the larger leaf tip with Burnt Sienna.

14. Add yellow color glaze. Dress a no. 10 filbert with medium mix and pick up a small amount of Yellow Light. Kiss the yellow areas and the tiger lily and leaf highlights with Yellow Light, allowing some of the white highlights to remain visible. Now add a small amount of Tangelo Orange to the Yellow Light glaze and brush the highlights on the tiger lily. Brush the leaf highlights with Yellow Light + a touch of Black Forest Green. Also use this mixture on the stems with a no. 4 liner.

Tip of the Brush

Yellow Light is a very intense color. A little bit goes a long way, so be sure to thin the paint with medium mix.

16. Add purple glaze. Mix Blue Violet + Napa Red (2:1) to create a purple color. Thin the color with medium mix. Using a no. 10 flat, float the purple on the deepest shadows of the hydrangea, especially along the bottom edge to help create the curve. Put a very weak touch of the purple near the center of the coreopsis to define the petals.

Paint the bee's upper body and head, and add his legs and body details with the purple mixture.

With a no. 4 filbert and Warm White + a touch of Blue Violet, drybrush the leaves where the blue of the hydrangea reflects onto them. Also drybrush the petals of the tiger lily where the blue of the hydrangea is reflected.

17. Add background interest. Cover the flowers with pieces of torn paper towel. Alternately spatter the painting with Honey Brown, Tangelo Orange, Olive Green and Blue Violet (see page 21).

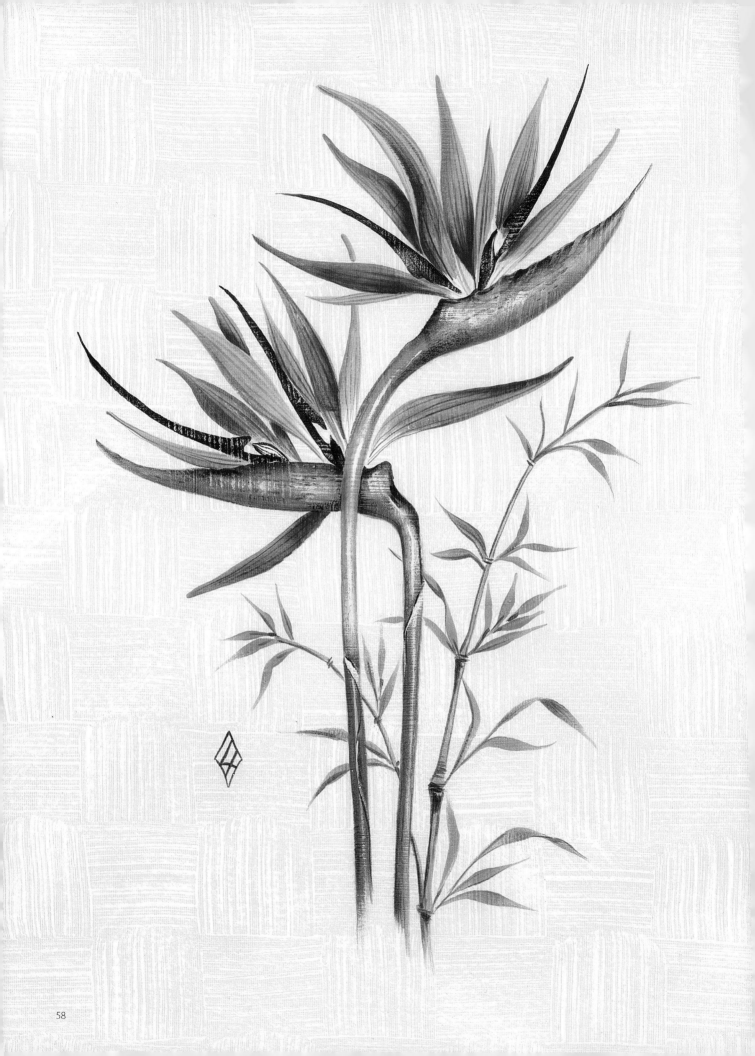

Exotique

Sometimes a floral arrangement can be inspired by an unusual shape or an intriguing color combination. This bird-of-paradise bouquet incorporates an angular layout and a triadic color harmony of orange, purple and green. Isn't nature mysterious and wonderful?

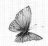

"My thoughts are dancing flowers and joyful singing birds."

—W.H. DAVIES

PALETTE: DECOART AMERICANA ACRYLICS

Warm White

Cadmium Yellow

Tangelo Orange

Santa Red

Blue Violet

Evergreen

Forest Green

Olive Green

Honey Brown

BACKGROUND COLOR

Light Mocha

Materials List

Brushes: nos. 8 and 10 flats, no. 4 liner, nos. 4 and 8 filberts, no. 10/0 mid-liner, 1-inch (25mm) angular bristle

Additional materials: DecoArt Decorating Paste; tooth-edged graining tool; spattering tool; palette knife; DecoArt Easy Float; DecoArt Faux Glazing Medium

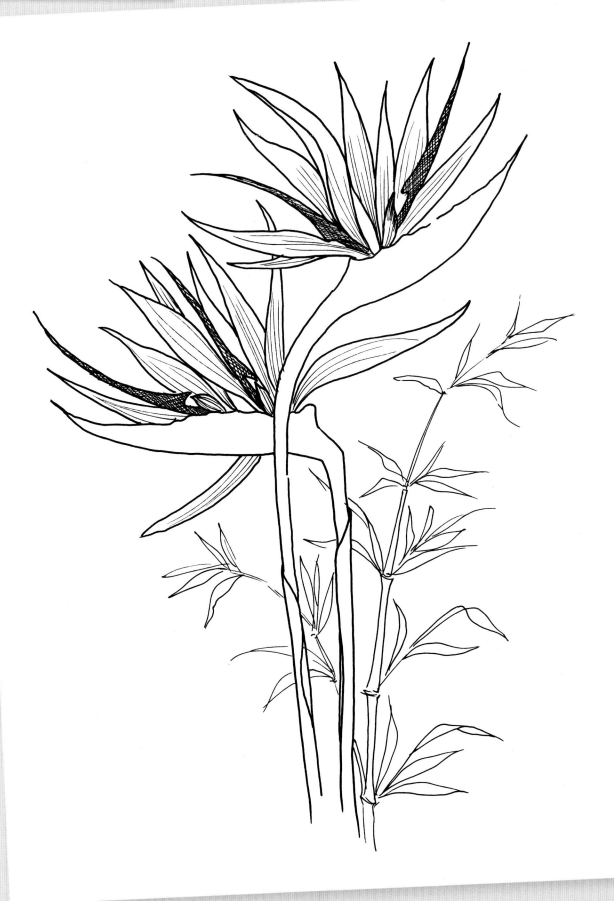

This pattern may be hand-traced or photocopied for personal use only.
Enlarge at 113% on a photocopier to bring it up to full size.

Before you paint. Prepare the background texture as described on page 22. Once the surface has been properly prepared and dried, trace and transfer the pattern.

1. Establish the flower sheaths and stems. With a no. 8 filbert, wash the sheaths and stems with Olive Green thinned with medium mix (page 20).

2. Develop the flower sheaths and stems. Using a no. 8 flat, float Forest Green along the bottom and left sides of the sheaths and stems. Then float Honey Brown along the opposite edges of the stems. Float a thinned purple (Santa Red + Blue Violet [1:1]) along the upper edges. Use short strokes to create texture along the upper edges.

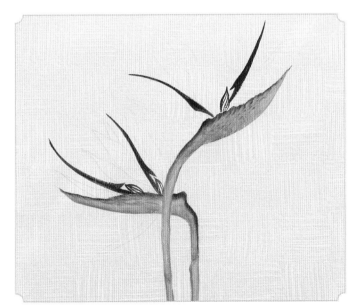

3. Develop the stamens. Place dark purple stamens with Blue Violet + Santa Red (2:1) using a no. 4 liner.

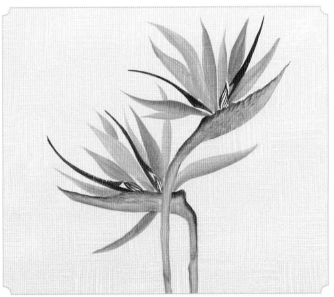

4. Develop the flower petals. With a clean no. 4 liner, stroke individual petals with a variety of brush-mixed hues created from Cadmium Yellow and Tangelo Orange. Give each petal a slightly different hue.

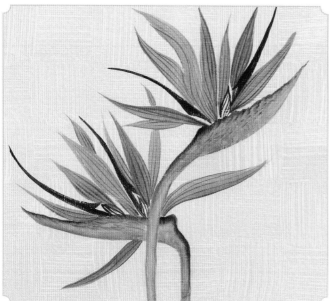

5. Detail the flower petals. Add vein lines with a no. 10/0 mid-liner. Use various shades of Tangelo Orange and red-orange (brush-mix of Tangelo Orange + Santa Red) as needed for contrast.

6. Shade the flower petals. Shade the petals by floating darker-value orange and red-orange hues with a no. 8 flat to help differentiate between the petals.

7. Highlight the sheaths. With a no. 4 filbert, drybrush highlights with Warm White to accentuate the underlying texture on the sheaths. Use the chisel edge of the brush to draw white highlights down the center of each stem. If the Warm White fades as it dries, apply a second layer of highlights.

8. Add the bamboo. Place the bamboo with a no. 4 liner and paint thinned with medium mix so it is semitransparent. The colors should recede and remain secondary to the main flowers. Place the stems with a Honey Brown wash. Detail with Honey Brown outlines, and shade with a mixture of Honey Brown + purple (Blue Violet + Santa Red [1:1]). Stroke leaves with various brush-mixes of Honey Brown and Olive Green. Try to lay the bamboo in with simple strokes to create a more spontaneous feel.

9. *Add final glazes to sheaths.* With a no. 10 flat dressed with medium mix, adjust the colors on the sheaths and stems. Side-load tints of Honey Brown in the warm highlighted areas. Place red/violet and purple on the top of the sheath (keep the purple in the coolest shadows). Float Evergreen along the underside of the sheaths and along the stems to create the fold. Use less and less color with each layer.

Tip of the Brush

The most intense colors, greatest contrasts and sharpest details are reserved for the focal point of the design.

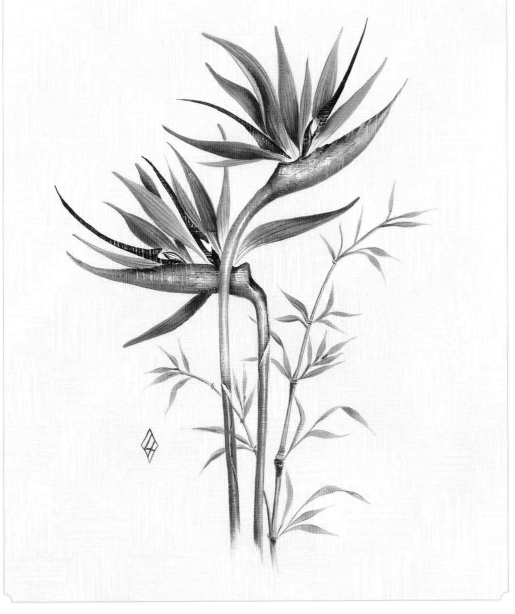

10. Add final highlights. Drybrush final highlights with Warm White.

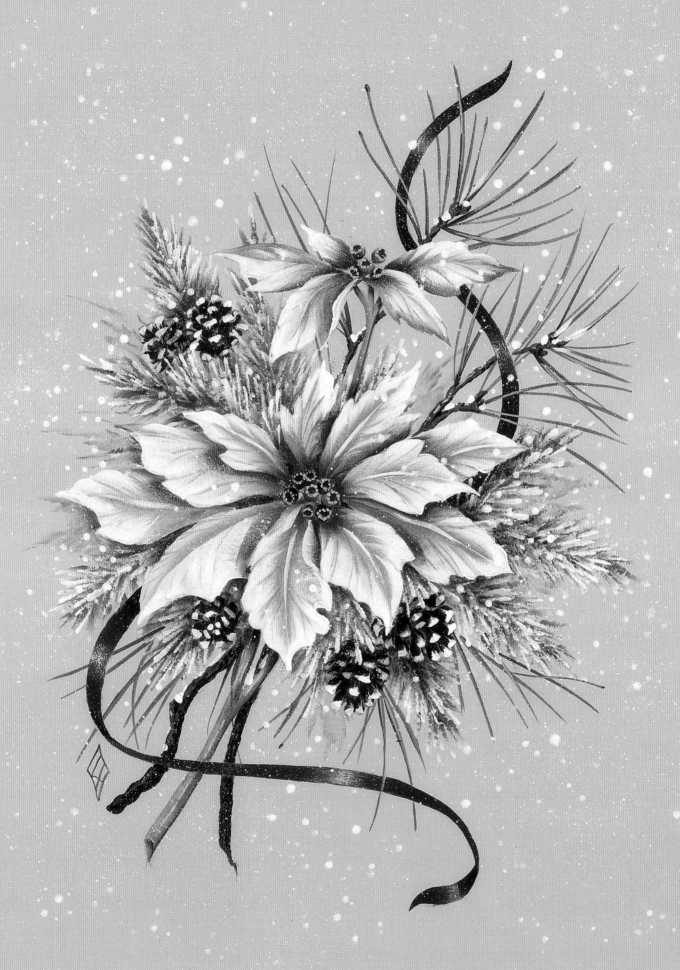

Noel

The traditional red and green Christmas palette is softened by the addition of white to create a range of clear tints. The poinsettia and ribbon are protected by an application of masking fluid as the greenery is developed.

*"Mirth at all times
all together
Make sweet May of
winter weather."*

—ALFRED DOMETT

PALETTE: DECOART AMERICANA ACRYLICS

Warm White

Light Mocha

Cadmium Yellow

Tangelo Orange

True Red

Napa Red

Payne's Grey

Olive Green

Evergreen

Black Forest Green

Honey Brown

Burnt Umber

BACKGROUND COLOR

Soft Sage

Materials List

Brushes: no. 2 script liner, nos. 8 and 12 flats; nos. 10/0 and 1 mid-liners; no. 2 filbert; ¼-inch (4mm) and ⅜-inch (10mm) angled shaders

Additional materials: blue masking fluid; old round brush; art eraser; bar of soap; DecoArt Easy Float; DecoArt Faux Glazing Medium; toothbrush or large, stiff brush for spattering

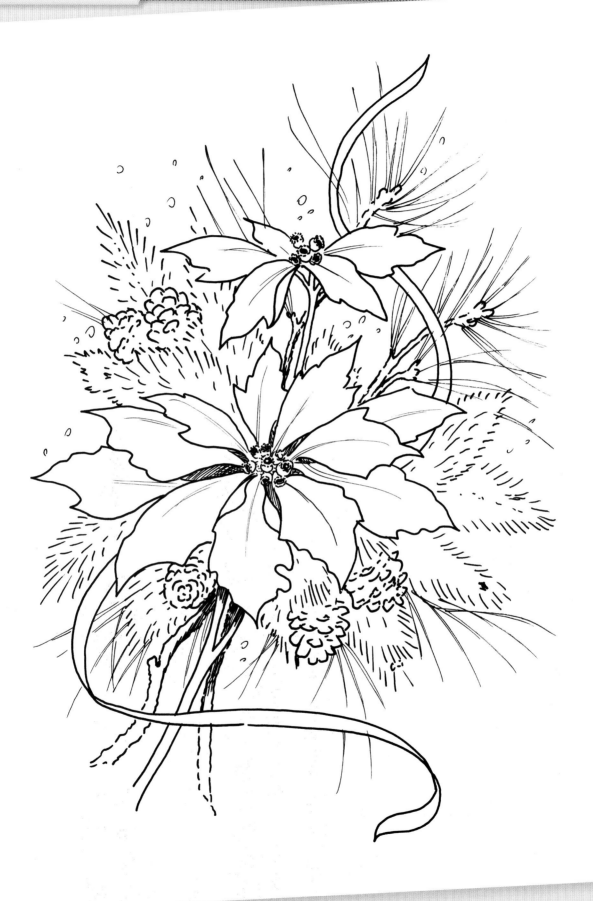

Before you paint. Basecoat your surface with Soft Sage. Trace and transfer the pattern.

1. Apply masking fluid. Dampen a brush and run it across a bar of soap, and then dress it with blue masking fluid (see page 20). I use an old, round brush for this task. Apply the masking fluid to the large poinsettia, paying close attention to stay within the lines of your tracing, especially near the edges and at the negative spaces found in the center of the flower. Let dry.

2. Develop the background. Place the ribbon with True Red using a no. 2 script liner. (Using the mask allows you to carry the ribbon right through the poinsettia.) Establish the stems with the no. 2 script liner dressed with Honey Brown and side loaded with Burnt Umber. Note the rough texture of the evergreen stems. Place the pinecones with a no. 2 filbert double loaded with Honey Brown and Burnt Umber. Use short, form-following strokes to set up the shape and texture for the finished cone.

3. Place the evergreen branches. Layer the evergreen branches using a no. 12 flat double loaded with Warm White and a teal mixture of Black Forest Green + Warm White + Payne's Grey (3:1:1). Using the chisel edge of the brush, tap the needles onto the branches, keeping the teal color facing the branch. Wipe and reload the brush frequently to keep the light and dark colors separate. Be sure to work into the negative spaces in the center of the poinsettia, darkening this area with more Black Forest Green and Payne's Grey. Let dry.

Tip of the Brush

Rinse and reload your brush often to avoid paint buildup in the ferrule.

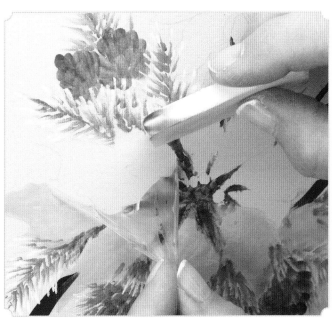

4. Remove masking fluid. Lift the edges of the masking fluid gently with an art eraser, and carefully pull the mask from the surface. Tidy the edges with the eraser. Dust away particles with a clean, dry paper towel.

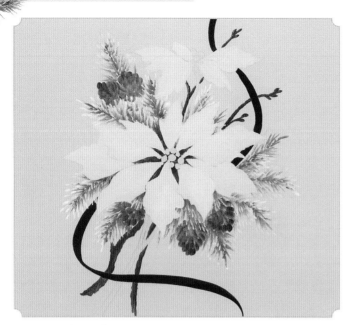

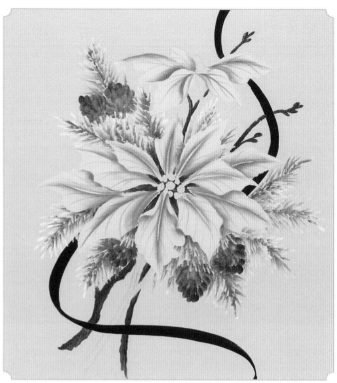

5. Basecoat the petals. Base the poinsettias' petals with Light Mocha using a no. 8 flat.

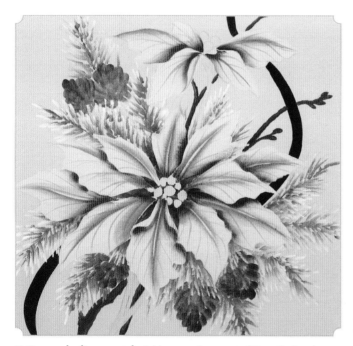

6. Detail the petals. Paint veins with a no. 1 mid-liner and a thinned pink mixture of Light Mocha + True Red (1:1), taking care not to paint the veins too dark. Pull secondary veins outward from the center vein, following the natural curve of the petal.

Use a no. 8 flat and the pink mixture to float shading along both sides of the center veins. Let dry. Separate the individual petals with floats of the same pink mixture.

7. Deepen shading on petals. Add an equal amount of Napa Red to the pink shading mixture. Float this color into the deepest shadows, separating the petals, with the no. 8 flat.

Tip of the Brush

To prevent paint from lifting when shading the poinsettias' petals, float the color along both sides of all center veins first and allow drying time before laying in the shadows separating the petals.

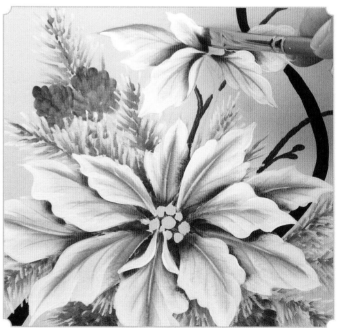

8. Highlight the petals. Highlight the edges of the petals with Warm White floated on with ¼-inch (6mm) and ⅜-inch (10mm) angle shaders. Use short, floated strokes instead of following the entire contoured edge. Build up heavy paint on the top-lying edges to pull them forward. Do not overwork the highlights.

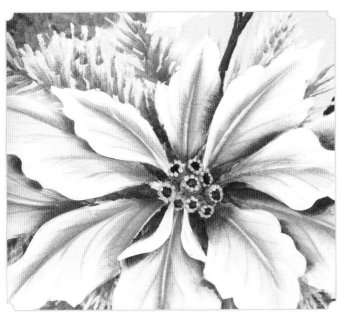

9. Paint the poinsettia's center. Paint the center florets with a no. 1 mid-liner. Each floret is a small ball of Olive Green, shaded with Evergreen and detailed in the center with a red-orange dot surrounded by tiny dabs of yellow.

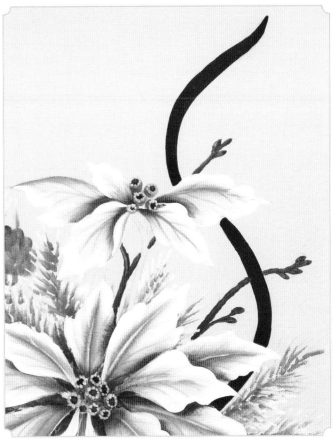

10. Shade the ribbon. With a no. 8 flat, float Napa Red where the ribbon disappears behind a petal and where it flips in front of the branches. Deepen the shading with a brush-mix of Napa Red and Payne's Grey.

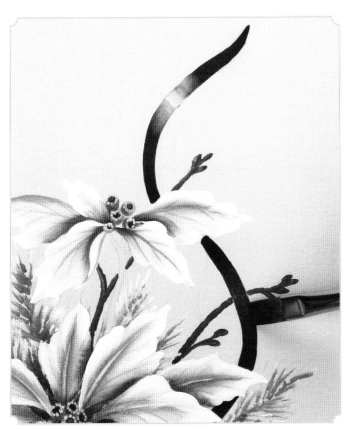

11. Highlight and glaze ribbon. With a clean no. 8 flat, highlight the center of each ribbon section with a back-to-back float of white. Let dry. Glaze the highlighted area with a brush-mix of Tangelo Orange + True Red. Let dry. Drybrush the final highlights with Warm White.

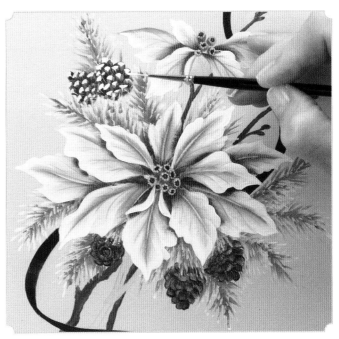

12. Detail the pinecones. Detail each petal of the pinecones with a no. 10/0 mid-liner and a mixture of Burnt Umber + Payne's Grey. Add a dab of "dirty white" from your palette to the tip of each petal using the point of the liner. Note the direction each form is facing.

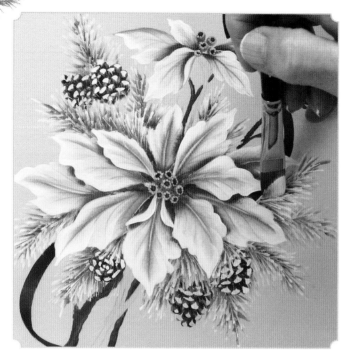

13. Add more needles. Add another layer of evergreen needles with a no. 12 flat double loaded with Warm White and a mixture of Evergreen + Black Forest Green. Remember to keep the light color facing away from the branch. Clean the brush and add a final layer with side-loaded Warm White only.

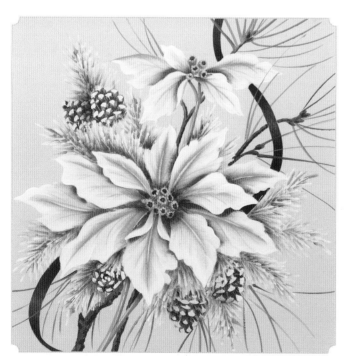

15. Glaze the shadows. Remember to remove any graphite transfer lines before you begin glazing to prevent the glaze from sealing the lines. Deepen the evergreen shadows behind the poinsettia and separate pinecones with tints of Payne's Grey floated on with a no. 12 flat. These blue shadows should be added to all triangle-shaped spaces.

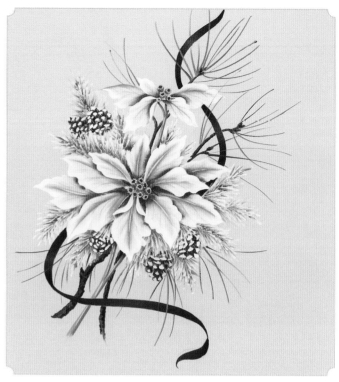

14. Paint the long pine needles and poinsettias' stems. Place the white pine's long needles with a no. 2 script liner double loaded with Olive Green and Evergreen. Place some of the needles behind the ribbon and others in front of it to give the ribbon the appearance of weaving through the branches.

Still using the no. 2 script liner, base the poinsettia branches with Olive Green. Shade with Evergreen and highlight with Warm White. Push back stems behind petals with a floated Evergreen + True Red mixture. Use the no. 1 mid-liner to roughly shade the Evergreen branches with irregular patterns of Burnt Umber and Payne's Grey.

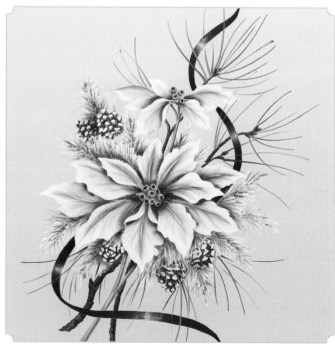

16. Glaze the poinsettia. Accent the poinsettia shadows with tints of Napa Red on a no. 12 flat.

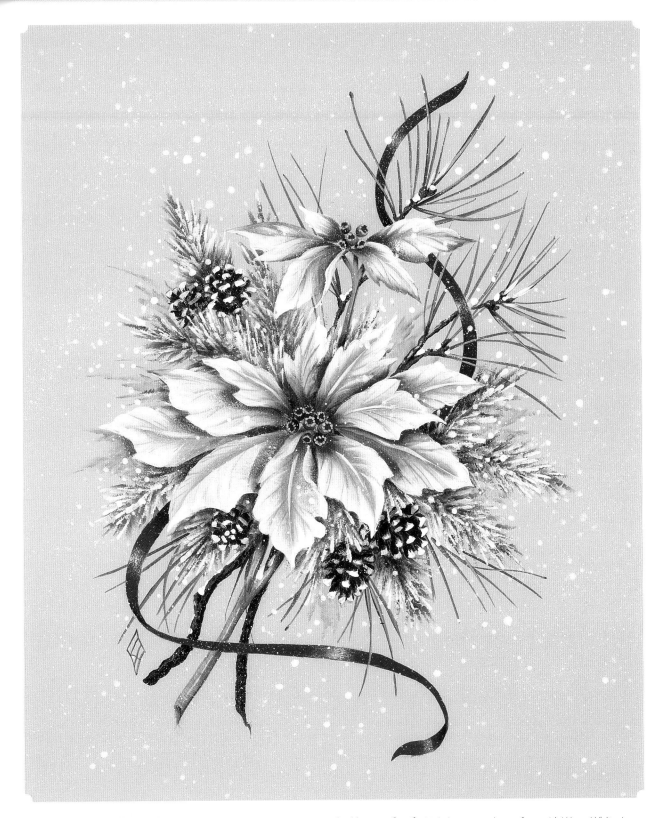

Tip of the Brush

When transferring a pattern, keep your lines faint and brief, eliminating any unnecessary details. Gently remove all telltale transfer lines as soon as the initial colors have been laid in.

17. Spatter and add snowy details. Lightly spatter the surface with Warm White. Lay heavy snow on branches and pinecones with a no. 1 mid-liner. Add large flakes of "falling snow" with a stylus or the point of a round brush. Lightly tap wet dots with your finger and then retouch the paint elsewhere onto the background, creating a variety of soft-focus snowflakes.

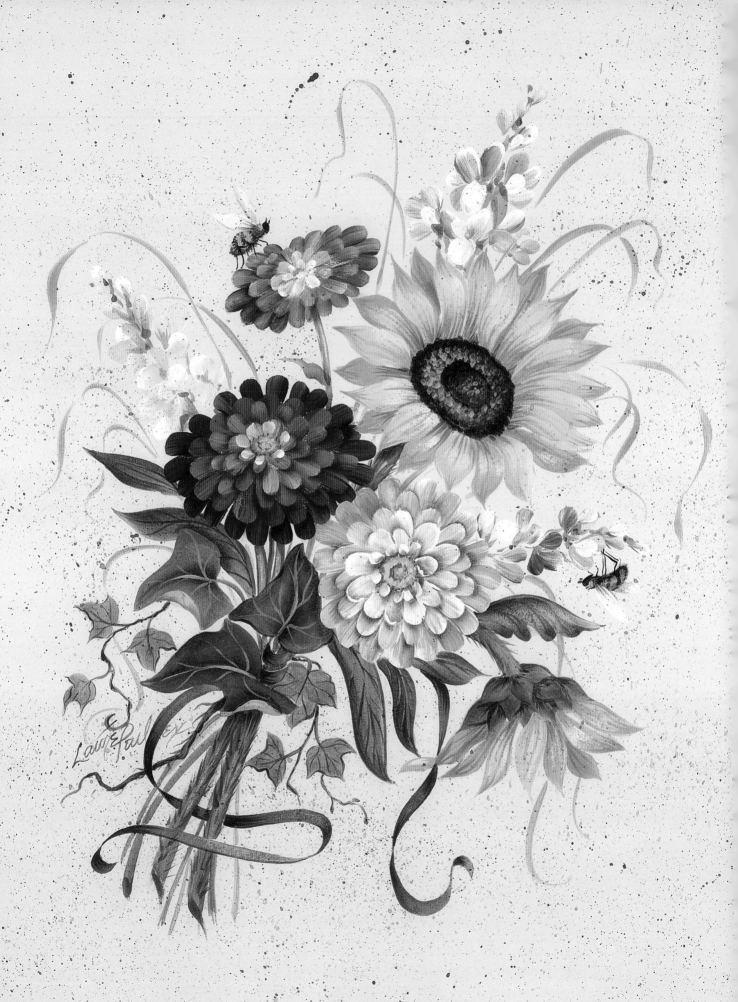

Rainbow Mix

Who can resist a riot of colorful blossoms? Here is your chance to use the full spectrum of colors on your palette. Just for fun, you might even substitute a few of these flower species with your own favorites. Be free!

"Sweet is all the land about, and all the flowers that blow."
—ALFRED LORD TENNYSON

PALETTE: DECOART AMERICANA ACRYLICS

Warm White Cadmium Yellow Yellow Light Tangelo Orange Santa Red

Napa Red Blue Violet Olive Green Forest Green Evergreen

Honey Brown Burnt Sienna Burnt Umber

BACKGROUND COLOR

Blue Chiffon

Materials List

Brushes: nos. 6 and 8 flats; no. 4 liner; no. 2 script liner; nos. 2, 4 and 6 filberts; nos. 10/0 and 1 mid-liners

Additional materials: DecoArt Easy Float; DecoArt Faux Glazing Medium; toothbrush or large, stiff brush for spattering

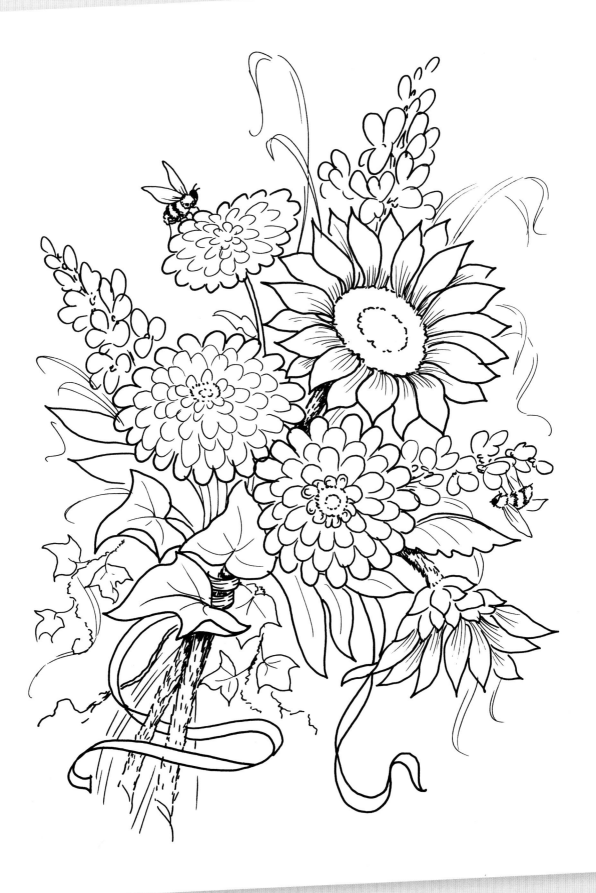

This pattern may be hand-traced or photocopied for personal use only.
Enlarge at 111% on a photocopier to bring it up to full size.

Before you paint. Paint the background Blue Chiffon. Trace and transfer the pattern.

1. Paint the ribbon and basecoat the leaves. Stroke in the ribbon with a mixture of Blue Violet + Warm White using a no. 4 liner. Shade with Blue Violet. Drybrush a highlight at the center of each section with Warm White.

Establish stems and leaves with Olive Green and Forest Green mixtures. Use a no. 4 liner for the stems and assorted small filberts for the leaves. Establish the stems of the delphiniums with Yellow Light + a touch of Forest Green. Stroke in the filler grass with graceful thin-thick-thin strokes of a Honey Brown + Warm White mixture using a no. 2 script liner.

2. Shade the leaves. Use a no. 8 flat sideloaded with Evergreen to float shading on the leaves. Note the placement of shading on the ivy; some leaves are left unshaded to add variety to the composition.

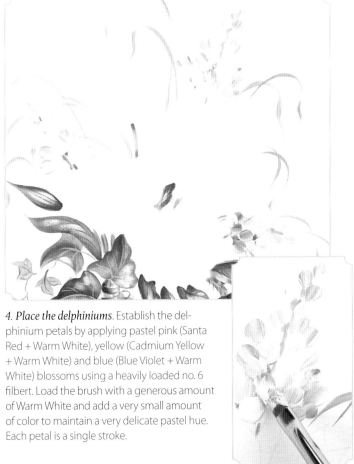

3. Detail and highlight the leaves. Use a no. 10/0 mid-liner to place the veins with Olive Green or Forest Green, depending on whether the detail is on a light or dark leaf. Paint the ivy veins using a mixture of Olive Green + Warm White. Drybrush highlights of Warm White using a no. 2 filbert. Remember: The Warm White is applied as a reflective base that will support the transparent glaze colors to be added at the end of the lesson. The chalky appearance of the Warm White will disappear after the final glazing is applied.

4. Place the delphiniums. Establish the delphinium petals by applying pastel pink (Santa Red + Warm White), yellow (Cadmium Yellow + Warm White) and blue (Blue Violet + Warm White) blossoms using a heavily loaded no. 6 filbert. Load the brush with a generous amount of Warm White and add a very small amount of color to maintain a very delicate pastel hue. Each petal is a single stroke.

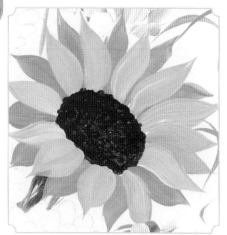

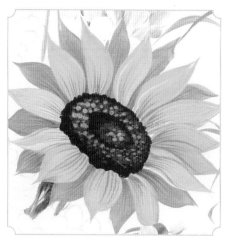

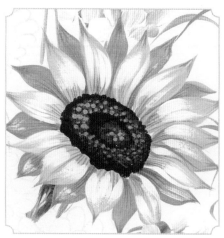

5. *Basecoat the sunflowers*. Place the underlying sunflower petals with a no. 4 liner loaded with Cadmium Yellow and tipped in Honey Brown. Begin each stroke at the base of the petal and pull outward toward the tip.

For the top-lying petals, load the no. 4 liner with Cadmium Yellow + a touch of Warm White. Keep a generous amount of paint in the brush. Several strokes may be used to form each petal.

Tap in the center with textured dabs of Burnt Sienna generously loaded on a no. 4 liner. Be sure to maintain an oval shape for the center.

6. *Detail the sunflowers*. Detail the sunflower petals with veins of Honey Brown + Tangelo Orange using a no. 1 liner. Pull the veins outward from the base of the petals.

Shade the center with dabs of Burnt Umber. Build highlights in the center with layers of Honey Brown followed by Tangelo Orange and Cadmium Yellow. Refer to the photo above for color placement.

For more detailed instructions on painting some of these flowers, refer to my book *Fast & Fun Flowers in Acrylics*. I have used the same methods from that book whenever possible in these lessons.

7. *Highlight the sunflowers*. Drybrush highlights on the petals with Warm White using the no. 4 liner or a no. 2 filbert. Place highlights wherever the petal is curved or on top-lying edges.

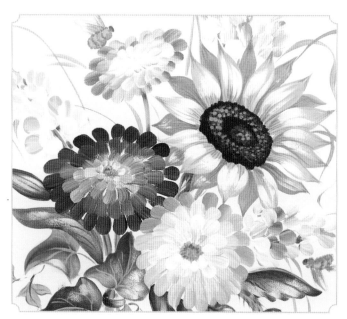

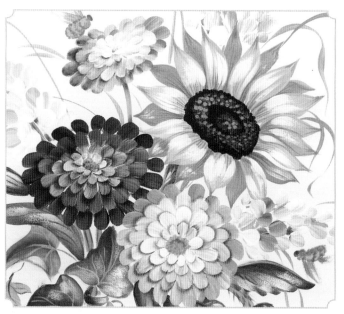

8. *Add the zinnias*. Layer the blue zinnia with Blue Violet and Warm White mixtures using nos. 2 and 4 filberts. Stroke the red zinnia with layers of Napa Red + Warm White using nos. 2, 4 and 6 filberts. Stroke the pink zinnia using layers of light pink (Warm White + a touch of Santa Red) and Warm White using nos. 2, 4 and 6 filberts. Be generous with the amount of paint in your brush to allow for dimensional, textural strokes. Pick up more Warm White and make the colors softer as you move toward the center of each zinnia.

Tap in the centers of all three zinnias with Cadmium Yellow and Honey Brown double loaded on the tip of the no. 2 filbert.

9. *Shade the zinnias*. Separate the zinnia petals by floating darker color values along the underlying edges with a no. 6 flat. Follow the curve of each petal to create a cast shadow on the underside.

Shade the blue zinnia with a Blue Violet + Napa Red mix.

Shade the larger petals on the red zinnia with the same mixture used for the blue zinnia. Shade the petals closer to the center with Napa Red. Shade the pink zinnia with a very thin, weak mixture of Santa Red + Napa Red.

10. Highlight the zinnias. Add final highlights to raise selected petal edges. Float with a heavy side load of Warm White on the edge of a no. 2 filbert. Concentrate most of the highlights on the pink zinnia, as it is in the center of the interest. To accent the pollen centers, dab with Cadmium Yellow + Warm White on the point of the no. 1 liner.

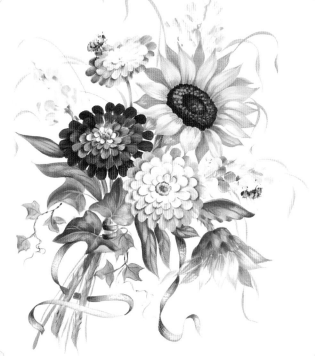

11. Add glazes of color. Dress a no. 8 filbert with medium mix (see page 20) and thin Yellow Light to a transparent color. Stroke this over the highlights on the sunflower petals. Add just a touch of Forest Green to the Yellow Light glaze to create a yellow-green for the leaves. Glaze Tangelo Orange over random edges of the small ivy leaves, zinnia centers and in the shadows of the sunflower petals.

12. Paint the bees and spatter. Tap color on the bees with the point of a no. 4 liner. Use Cadmium Yellow for the bodies. Shade and place wings with thinned Honey Brown. Detail with Burnt Umber + dark purple (Blue Violet + Napa Red). Overstroke the wings with thinned Warm White.

Spatter the background alternately with Olive Green, Forest Green, Honey Brown and Blue Violet (see page 21).

Tip of the Brush

The most intense colors, greatest contrasts and sharpest details are reserved for the focal point of the design.

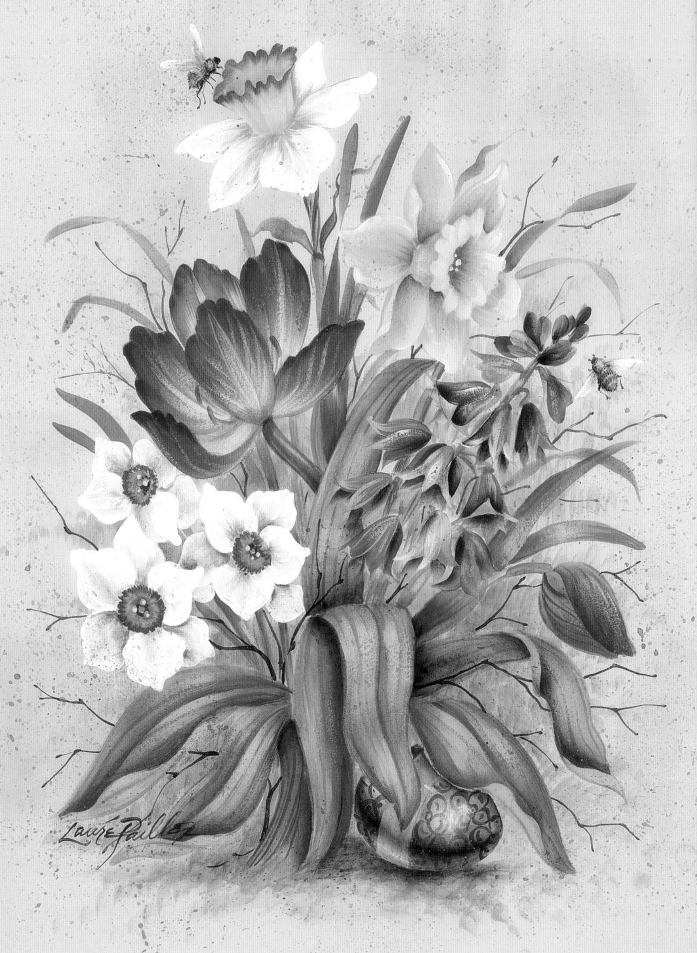

Think Spring!

Spring bulbs speak of hope, renewal, rebirth—joyful things! Although this busy arrangement seems to be "planted" in the spring earth, it could be placed into a twiggy basket, or the elements could be used individually as miniature bouquets.

"And then my heart with pleasure fills, And dances with the daffodils."

—WILLIAM WORDSWORTH

PALETTE: DECOART AMERICANA ACRYLICS

Snow (Titanium) White

Warm White

Cadmium Yellow

Yellow Light

Tangelo Orange

Napa Red

Blue Violet

Olive Green

Forest Green

Evergreen

Honey Brown

Burnt Sienna

BACKGROUND COLOR

Light Parch-ment

Materials List

Brushes: nos. 2, 8 and 10 flats; no. 4 liner; nos. 2, 4, 8 and 10 filberts; nos. 10/0 and 1 mid-liners; ½-inch (12mm) angular bristle

Additional materials: DecoArt Easy Float; DecoArt Faux Glazing Medium; toothbrush or large, stiff brush for spattering

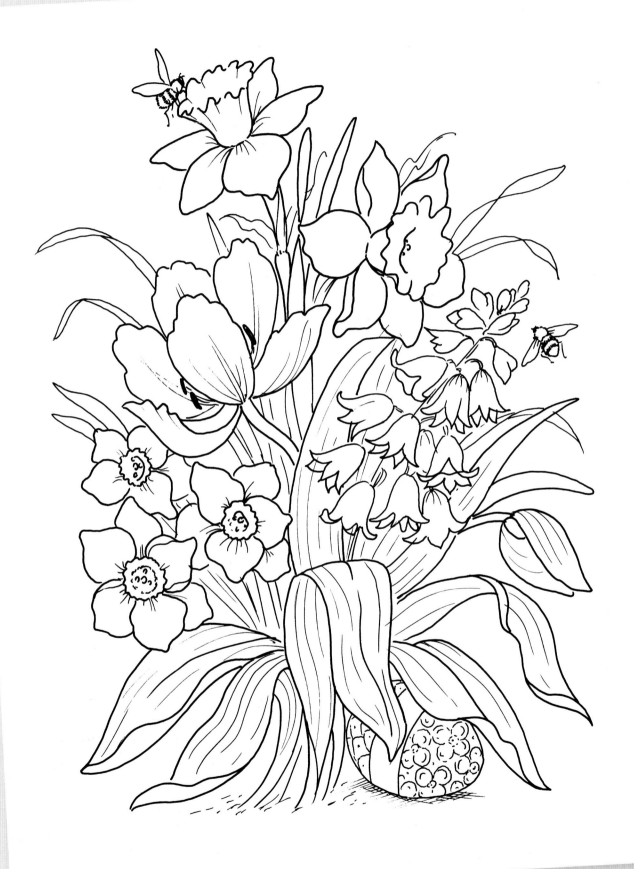

Before you paint. Basecoat your surface with Light Parchment. Trace and transfer the pattern.

1. Basecoat the petals. Use a ½-inch (12mm) angular bristle to drybrush the background surrounding the design with a mixture of Snow (Titanium) White and Olive Green (4:1). Be careful to work around the transfer lines so as not to remove them. Base all white petals with Light Parchment + Olive Green (3:1) and a no. 4 filbert.

3. Fill the negative space. Fill the negative space between the elements with thinned Olive Green + Honey Brown brush-mixes using short, vertical strokes with a no. 8 filbert. Carry fern-like textured sprays outward onto the background beyond the flowers. This brings color and texture in between the flowers while still allowing light to pass through. Add a touch of Forest Green to the Olive Green + Honey Brown brush-mixes in the filler around the bottom leaves and the foreground.

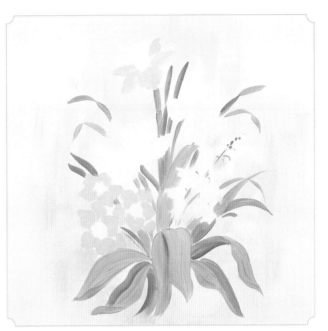

2. Basecoat the leaves. With appropriately sized filbert brushes, stroke leaves with a variety of brush-mixes made from Olive Green and Olive Green + Forest Green (2:1). Use medium mix (see page 20) to thin the paint in the brush to keep the background leaves semitransparent. Fill in the larger leaves around the flowers as needed.

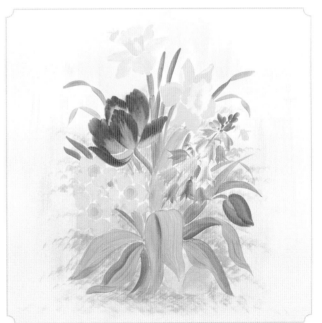

4. Place initial colors on the flowers. Use a variety of appropriately sized filbert brushes to place color on the flowers. Base the daffodils with Cadmium Yellow + a touch of Warm White.

Base the centers of the narcissus with Cadmium Yellow dabbed with Olive Green in the middle.

Base the tulips with Cadmium Yellow + a touch of Tangelo Orange on the inner petals and at the base of petals. Pull Tangelo Orange downward from the petal tips.

Paint the hyacinth using a variety of Blue Violet + Snow (Titanium) White brush-mixes. Use short strokes to establish the petals. Base the egg with light blue (Blue Violet + Snow [Titanium] White) using Cadmium Yellow + Warm White for the band. Develop the bees with yellow and brown hues as you work through the painting.

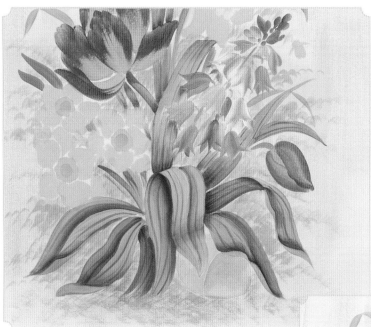

5. *Detail and shade the leaves.* Add details and veins to the leaves with a no. 1 mid-liner and Forest Green + Evergreen thinned with medium mix.

Note: The tulip leaves have parallel veins that follow the drape of the leaves. Use nos. 8 and 10 flats to float shading with the Forest Green + Evergreen mixture. Shade the back-lying edges wherever one leaf goes behind another to separate the leaves. Also float a shadow along the center veins.

6. *Deepen shadows on the leaves.* With the no. 10 flat, float Evergreen into the deepest shadows along the folds of the leaves to separate them. Pat some of this color beneath the egg and onto the foreground.

7. *Highlight the leaves.* Drybrush highlights with Warm White + a touch of Olive Green using a no. 4 liner flattened to create a square edge (see page 21). Place the highlights near the center of the curve on any raised planes or flipped edges.

Tip of the Brush

Highlights and shadows never overlap each other. They are never placed on top of each other.

Tip of the Brush

Carry a little medium in your brush to help strokes flow smoothly from your brush. Begin with a clean brush dampened with water and blotted onto a paper towel.

Rinse and reload your brush often to avoid paint buildup in the ferrule.

9. Finish the narcissus. Float a heavy edge of Snow (Titanium) White along the petal edges using a side-loaded no. 4 filbert. Concentrate the heaviest application on the top-lying petal edges. (Refer to the photo above to identify those edges.) This will make the top layers pop forward so they look dimensional.

Still using the no. 4 filbert, drybrush random shadows with touches of light blue (Snow [Titanium] White + Blue Violet). Keep these shadows primarily on the back petals.

8. Develop the narcissus. Float the outside edges of the white petals on the narcissus with thinned Warm White, walking the color inward using nos. 4 and 8 filberts. Reload the brush for each stroke.

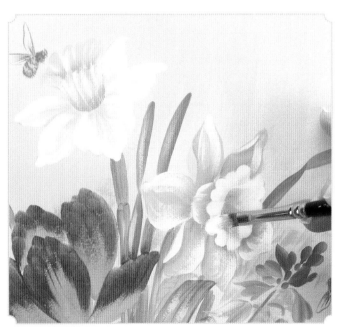

11. Highlight the daffodils. Drybrush highlights on petal edges with form-following strokes using a no. 4 filbert and Warm White. Pull from the outside edge of the ruffle toward the center.

Remember, the white highlights will be glazed with a transparent yellow, so the white provides a reflective background for the transparent yellow to follow.

10. Detail the daffodils and bees. On the daffodil, use a no. 8 flat and shade with a floated mixture of Cadmium Yellow + Honey Brown, pulling outward from the center of the flower. Remember to work the shading colors and details onto the bees when using the Honey Brown; darken with Burnt Sienna as needed. Use a no. 10/0 mid-liner for the bees.

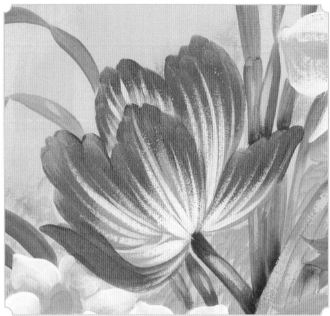

12. Highlight the tulips. Drybrush highlights and veining details on the tulip with Warm White and a no. 4 liner. Pull these details from the base of the petals.

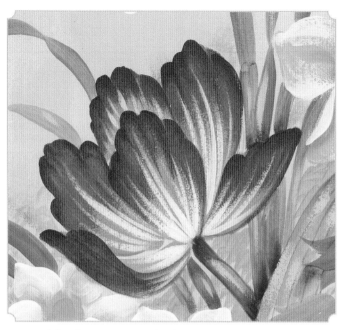

13. Detail the tulip. With a no. 10 flat, float a brush-mix of Tangelo Orange + Burnt Sienna on the petal tips.

14. Deepen the shading on the tulip. Float a second shading value in broken strokes along the petal tips with a mixture of Tangelo Orange + Napa Red using a no. 10 flat. Thin the paint with medium mix for transparency.

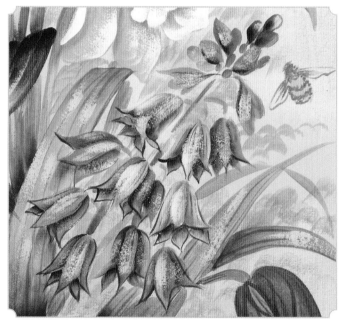

15. Finish the hyacinth. Load a no. 10/0 mid-liner with Blue Violet and define the individual petal edges of the hyacinth. Follow the pattern for petal placement since some petals overlap or peek out from behind other elements. Fill in any flipped petals with light blue (Snow [Titanium] White + Blue Violet). Use a no. 2 flat to float the shaded edges. Add detail veins with Blue Violet and a no. 10/0 mid-liner. Drybrush highlights on top-facing petals with Snow (Titanium) White + a touch of Blue Violet using a no. 2 filbert.

Tip of the Brush

Execute each stroke following the contour of the object, carrying the stroke through in a smooth, continuous motion.

16. Detail the egg. Apply decorative patterns to the egg with thinned Blue Violet using a no. 1 mid-liner.

17. Finish the egg. Float shading around the outside blue edges with Blue Violet using a no. 8 flat. Let dry. Apply a back-to-back float of purple (Blue Violet + a touch of Napa Red) ¼ inch (6mm) from the bottom edge as shown. Float shading on the yellow band with Honey Brown and the no. 8 flat. Add highlights with pivot floats (see page 22) of Warm White using a clean no. 8 flat.

18. Detail the bees and add filler branches. Finish the bees with shading details of Burnt Sienna + purple (Blue Violet + Napa Red) using a no. 10/0 mid-liner. Overstroke the wings with Snow (Titanium) White and a no. 2 filbert.

Paint the bare branches Burnt Sienna with a no. 1 mid-liner. Use a light hand for these details and let the branches break up the negative space to create added interest. Add the tulip stamens with a no. 1 mid-liner loaded with Honey Brown.

Use a no. 2 flat side loaded with Tangelo Orange to tint the ruffled edges on the yellow daffodil trumpet and the narcissus centers. Use broken strokes, allowing some yellow to show through.

Tip of the Brush

For "floated color," select a flat brush that is slightly larger than the area to be colored. Use clean water and/or extender medium to help the paint transition gradually from color-loaded edge into the clean edge. Place the entire width of the brush against the surface as you apply the stroke.

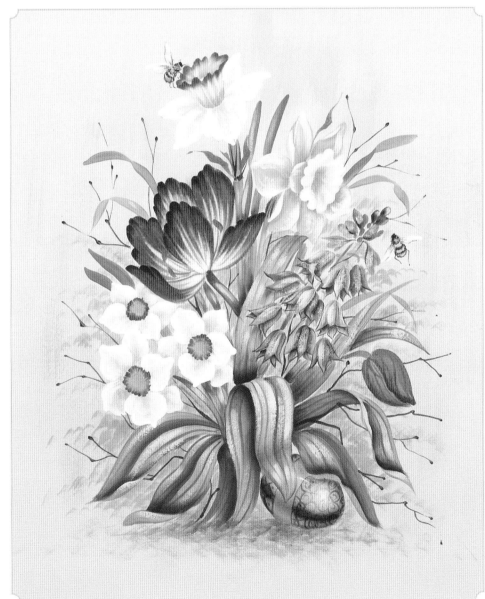

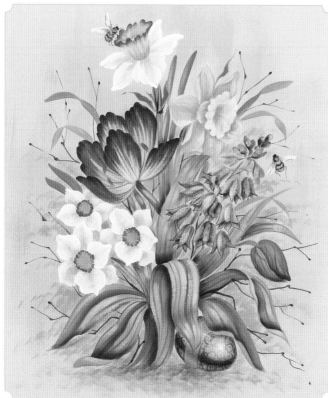

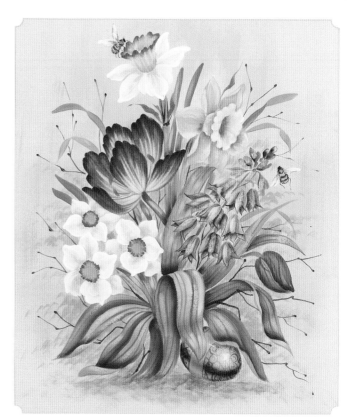

19. Apply a yellow glaze. Apply all glazes with various sizes of filbert brushes. Glaze Yellow Light on all yellow and orange elements. Glaze leaf highlights with Yellow Light + a touch of Forest Green.

20. Apply an orange glaze. Glaze Tangelo Orange on random leaf edges, on yellow elements and in the foreground. The orange on the leaves reflects some of the nearby flower color.

21. Apply a purple glaze. Glaze the purple mixture (Blue Violet + Napa Red) on the blue flowers, the foreground and on the deepest shadows of the white and yellow elements. Tints should be very weak on the white and yellow elements. Shade under the egg.

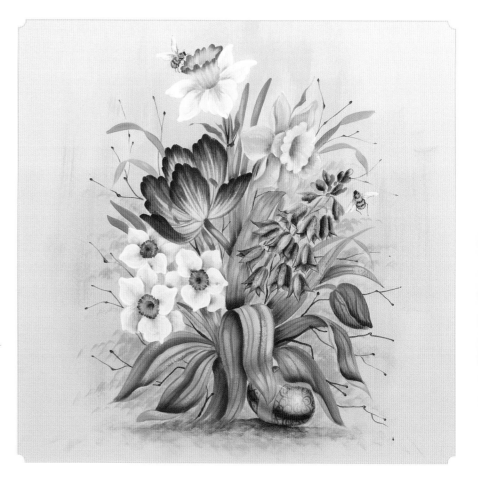

Tip of the Brush

Always choose a brush size relative to the size of the area or stroke to be painted.

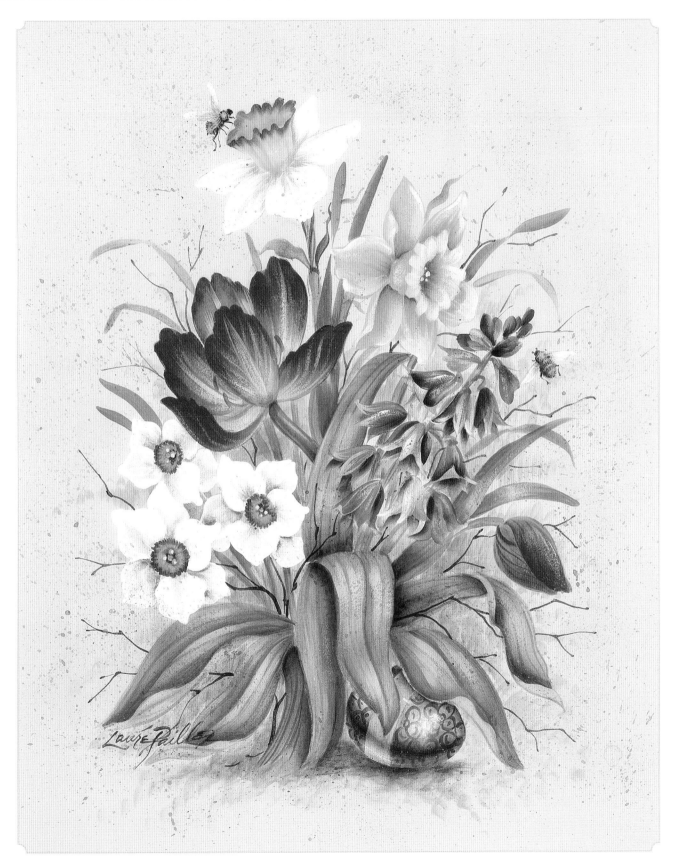

22. Add final details and spatter. Add stamens to the centers of the daffodils and narcissus with dabs of Cadmium Yellow + Snow (Titanium) White and a no. 10/0 mid-liner. Protect the central design area by covering it with a torn paper towel. Spatter the background alternately with Olive Green, Tangelo Orange and Blue Violet (see page 21). Add final highlights with Snow (Titanium) White as needed after the painting has dried.

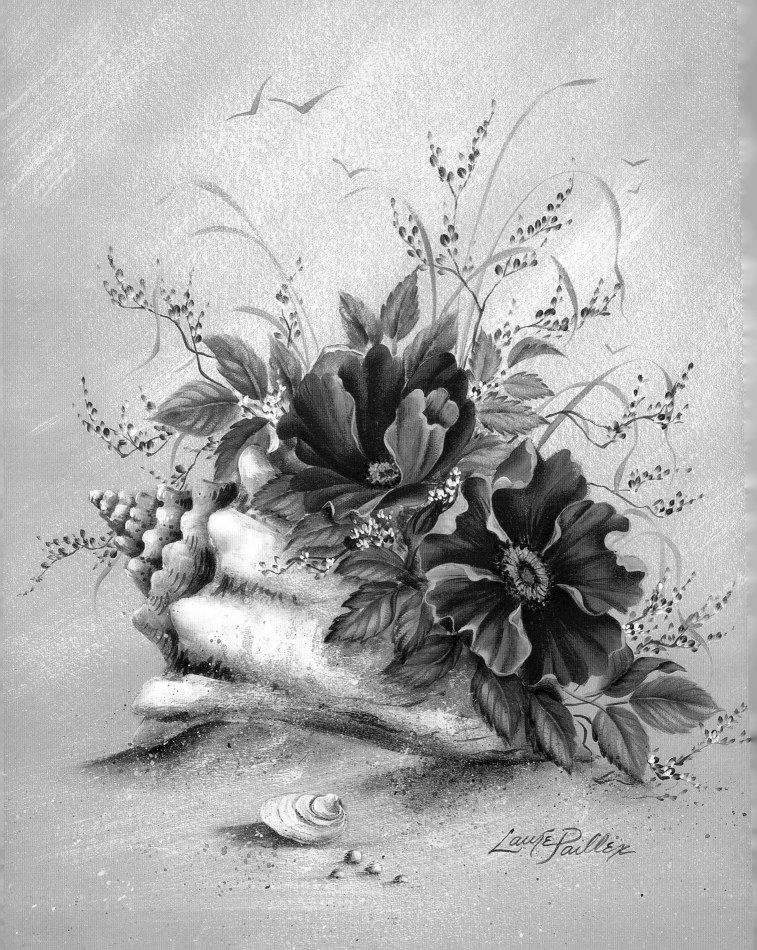

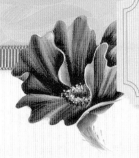

Seaside Beauties

Only the hardiest blossoms can weather the harsh ocean air. Salt spray roses and sea lavender make a fragrant bouquet; but wear heavy gloves and bring your clippers, for the rugged, thorny stems are perilous to touch! They are more fun to paint than to pick!

*"Breathe soft, ye Winds! Be calm, ye Skies!
Arise ye flow'ry Race, arise!"*
—WILLIAM BROOME

PALETTE: DECOART AMERICANA ACRYLICS

Snow (Titanium) White

Warm White

Cadmium Yellow

Yellow Light

Honey Brown

Santa Red

True Red

Napa Red

Dioxazine Purple

Payne's Grey

Forest Green

Burnt Umber

Shell Mixture*

*Shell Mixture =
Soft Lilac + Honey Brown + True Red
(2:1: touch)

BACKGROUND COLOR

Soft Lilac

Materials List

Brushes: nos. 2, 6 and 10 flats; no. 4 liner; nos. 2, 6 and 10 filberts; nos. 10/0 and 1 mid-liners; no. 2 script liner; 1-inch (25mm) angular bristle

Additional materials: DecoArt Easy Float; DecoArt Faux Glazing Medium; toothbrush or large, stiff brush for spattering

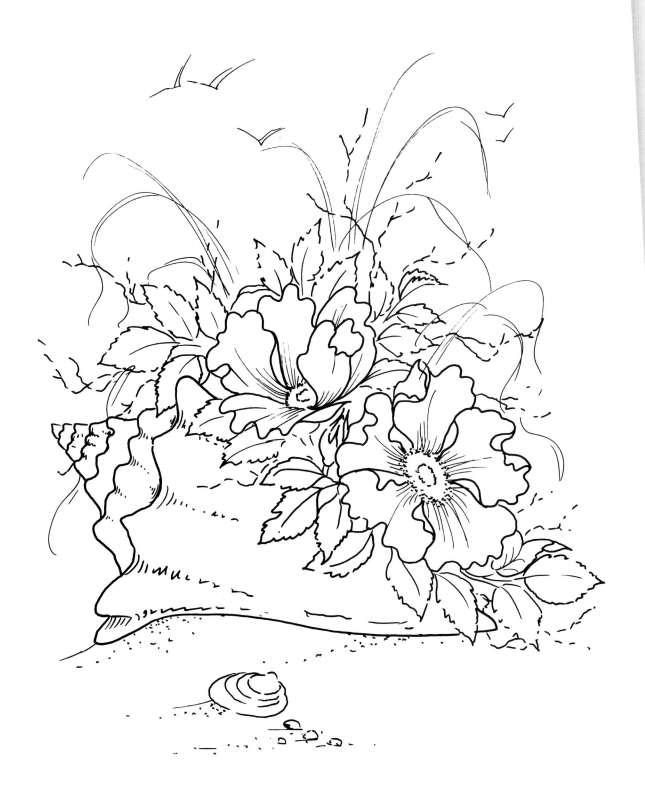

Before you paint. Basecoat your surface with Soft Lilac. Trace and transfer the pattern.

1. Outline the elements. Outline the main elements with a no. 4 liner and very thin paint. Outline the leaves and sketch the branches with Cadmium Yellow + a touch of Forest Green. Outline the shell with a mixture of Soft Lilac + Honey Brown + True Red (2:1: touch). Outline the flowers with Warm White + True Red (1:1). Remove transfer lines.

2. Place the sky and shell. Drybrush the sky with diagonal strokes of Warm White using a 1-inch (25mm) angular bristle, working over the outline. Keep the lightest patches directly behind the flowers and fade out toward the edges.

Use a variety of filbert brushes to lightly base the shells with a shell-color mixture of Soft Lilac + Honey Brown + True Red (2:1: touch). Allow some of the Soft Lilac background color to show through in the highlighted areas. Work around and between the leaves with a smaller brush. Be sure to fill in the negative spaces. With a no. 10 filbert, begin to brush the shell color diagonally onto the sand beneath the two shells.

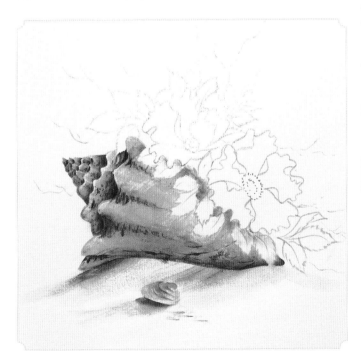

3. Shade the shell. Develop shadows along the ridges and the bottom of the shell with floated Burnt Umber using various sizes of flat brushes. Let dry. Use a no. 1 mid-liner to add details with Burnt Umber.

Tip of the Brush

Always choose a brush size relative to the size of the area or stroke to be painted.

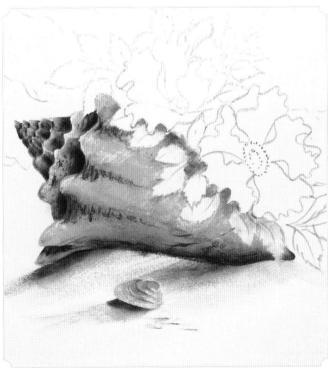

4. Deepen the shell's shadows. Float a mixture of Burnt Umber + Payne's Grey into the deepest shadows of the shell using a no. 10 flat.

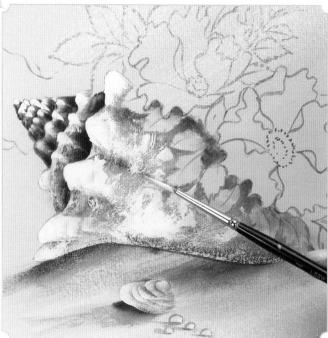

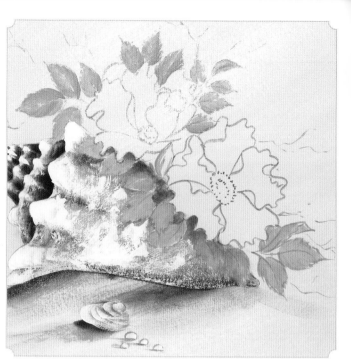

5. Highlight the shell. Develop highlights with floated Warm White using the nos. 2 and 10 flats. Drybrush Warm White along the bottom edge of the shell, allowing the previous shading layer to show through. Then load a no. 4 liner with Warm White and drag the side of the brush along the surface, allowing the color to skip and create texture along the gnarled ridges as shown.

6. Basecoat the leaves. Stroke the initial colors on the leaves with Cadmium Yellow + Forest Green on a no. 2 flat. Tender new leaves are lighter in value and have a nice touch of Honey Brown added. Allow some of the background sky light to show through to create sparkle.

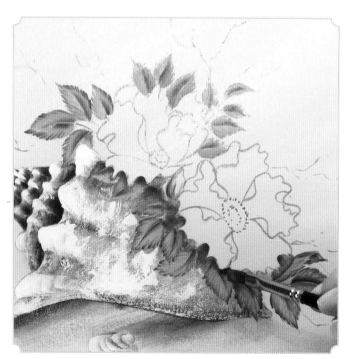

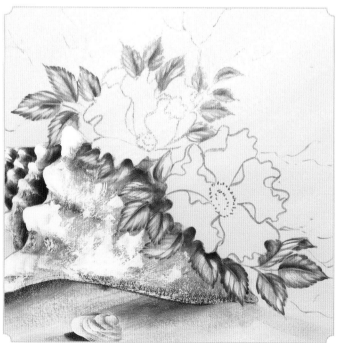

7. Shade the leaves. Dress the no. 2 flat in medium mix (see page 20) and side load it into Forest Green. Float along the center vein on each leaf. When the center veins are dry, go back and establish the serrated edges of the leaves. The second shading value is a mixture of Forest Green + Payne's Grey. Using a no. 6 flat, float this mixture halfway down the center veins, inside turned leaf edges and along edges where leaves are shaded by flowers.

8. Highlight the leaves. With Warm White on a no. 2 filbert, drybrush highlights on the curved part of each leaf where it catches the sunlight.

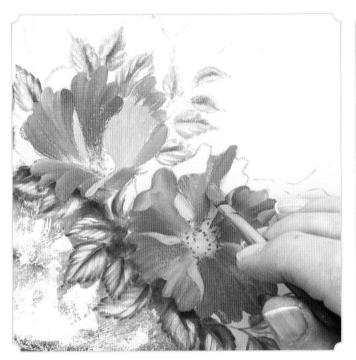

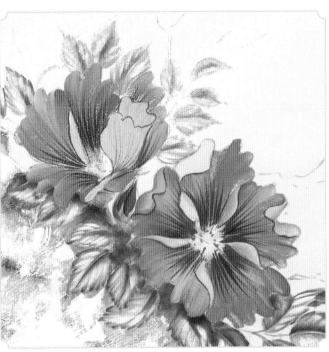

9. Basecoat the rose petals. Mix two distinct values of pink for the roses—a very light one and a dark one. The light-value pink is Snow (Titanium) White with just a touch of Santa Red. The darker pink is Snow (Titanium) White + Santa Red (1:1).

Load a no. 6 filbert with dark pink and dip just the tip of the bristles into the lighter pink. Pull long strokes to establish the ruffled petals, blending them only slightly so that each petal is distinguished from the next. Paint the backs of the front petals and any turned edges where you can see the backs of the petals with the light-value pink.

10. Detail the rose petals. Load a no. 1 mid-liner with a brush-mix of Santa Red + Napa Red and pull fine detail lines outward from the base of each petal, following the shape and contour of the petal. It will also help to outline the edges of the folded petal in the top rose (that is still somewhat closed). This petal will be shaded in the next step.

Tip of the Brush

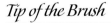

Take advantage of the rounded shape of the filbert brush to create the rounded top edge of each rose petal.

The size and shape of the object you are painting determines the size and shape of the brush you should use. Observing the object carefully will tell you, first, which shape of brush to use and, second, the size.

11. Shade the rose petals. With a no. 6 flat and a mixture of Santa Red + Napa Red, float shading under the turned edges and at the bases of the petals. Note how shadows fall behind and under the petal edges. To create dips in the ruffled edges, thin the same color mixture with medium mix to make a very weak color and pull strokes from the petal edge downward using a no. 2 filbert. Deepen shadows with floats of Napa Red on the no. 6 flat, mainly at the bases of the petals and in the deepest part of the curves under the turned edges.

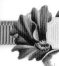

12. *Highlight the rose petals and detail the centers.* Using a no. 10/0 mid-liner, line the ruffled petal edges with a very light mixture of Snow (Titanium) White + a touch of light pink from your palette. Float highlights on turned petal edges using a no. 6 flat.

Stipple the rose centers with a no. 2 flat double loaded with Cadmium Yellow and Honey Brown. Maintain the oval shape while keeping the yellow facing upward. Tap pollen dots around the centers with a mixture of Napa Red + Burnt Umber using a no. 10/0 mid-liner, allowing some dots to sprinkle out onto the petals. Highlight the yellow pollen with dots of Snow (Titanium) White.

Finally, fill any negative spaces between the two roses (where the shell shows through) with a brush-mix of Burnt Umber + Payne's Gray.

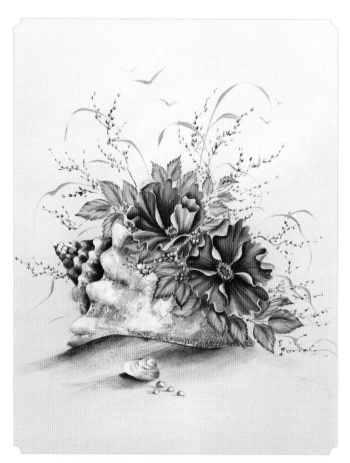

13. *Add the sea grasses and lavender.* Stroke the grasses with the no. 2 script liner and brush-mixes of Honey Brown + Snow (Titanium) White. Render the fine, irregular branches for the sea lavender with the point of the liner and a variety of greens from your palette.

Dot on the flowers of the sea lavender with the tip of the no. 2 filbert double loaded with Dioxazine Purple and Snow (Titanium) White. Set the knife-edge of the brush down on the surface with the white edge facing up to create little two-toned buds. Place these in clusters that get smaller and fewer toward the tip of the branch. Be sure to fill in among the roses and leaves. Once the color dries, add more white for contrast as needed, such as in the narrow space between the two roses.

Paint the seabirds and the shadows on the pebbles using a mixture of thinned Payne's Grey + Snow (Titanium) White. Highlight the sunlit side of the pebbles with Snow (Titanium) White.

14. *Add warm color glazes.* Glazing is done in order from warm to cool. The warm tints are on the highlights and the cool tints are on the shadows. Thin paints with medium mix and apply color with a large side-loaded flat or filbert brush. Work slowly with subtle layers of color, allowing them to dry between layers.

Start with the warm tints of Yellow Light on the flower centers; use Yellow Light + a touch of Forest Green on the leaves. The next tint is Yellow Light + Santa Red to make an orange. Tint the highlight areas of the shell with this color, leaving a lot of white showing. Tint the shell with very weak Santa Red near where the roses overlay the shell. Use this same tint of red along the serrated edges of several leaves.

Don't forget to add reflected colors in the sand under the shell using very weak tints of all your glazing colors.

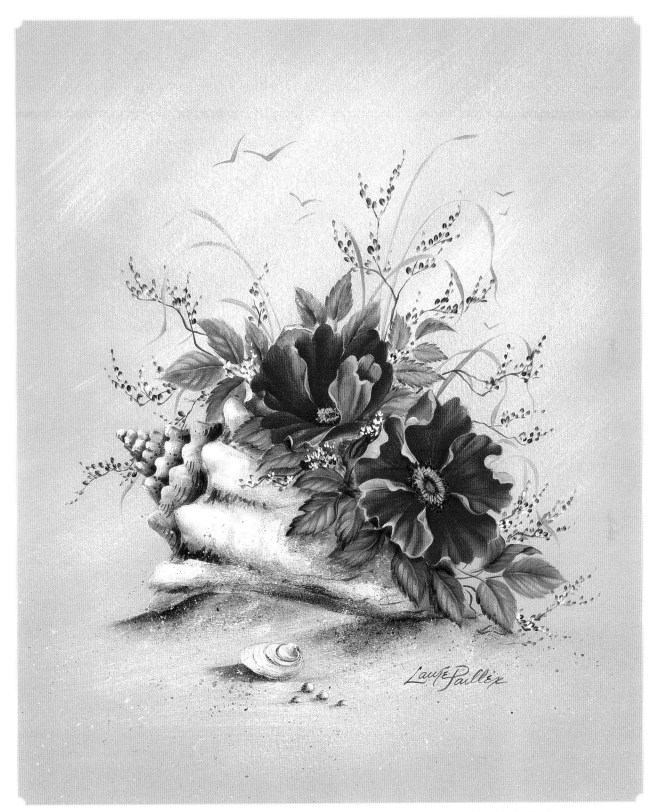

15. Add final glazes and spatter. Start the cool tints with Dioxazine Purple thinned with medium mix and applied with a large, side-loaded flat brush. Tint the bottom edge of the large shell and the shaded area of the small shell. Float tints in the deepest shadows on the rose petals, especially in the folds near the flower center.

With Payne's Grey thinned with medium mix, float tints on the large shell under the leaves to create cast shadows that lift the leaves away from the shell. Tint the leaves under the ruffled edges of the rose petals to lift them up and away from the leaves. Float final tints in the deepest shadows on the sand.

Cover the sky and flowers with paper towel, leaving only the bottom of the shell and the sand exposed. Finish with a spatter of Burnt Umber, then with Dioxazine Purple and finally with Snow (Titanium) White (see page 21).

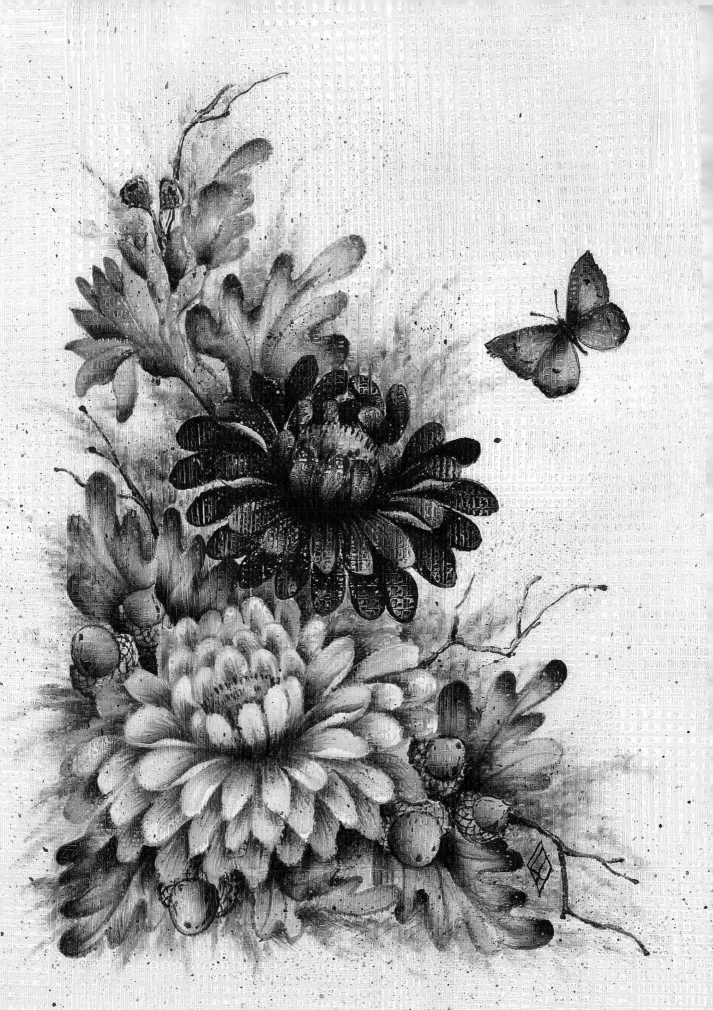

Autumn Glory

The dimensional texture applied to this background accentuates the dry-brushed leaves and flowers, giving a rustic, naturalized feeling to the composition. You can almost feel the crisp autumn air and hear the leaves crunching beneath your feet!

"Sing a song of seasons!
Something bright in all!
Flowers in the summer,
Fires in the fall!"
—ROBERT LOUIS STEVENSON

PALETTE: DECOART AMERICANA ACRYLICS

Warm White

Cadmium
Yellow

Yellow Light

 Tangelo
Orange

 Napa Red

Dioxazine
Purple

 Evergreen

 Honey Brown

 Burnt Umber

BACKGROUND COLOR

Light Mocha

Materials List

Brushes: nos. 6 and 10 flats; no. 4 liner; nos. 6 and 8 filberts; nos. 10/0 and 1 mid-liners; 1-inch (25mm) angular bristle

Additional materials: DecoArt Decorating Paste; tooth-edged graining tool; DecoArt Easy Float; DecoArt Faux Glazing Medium; toothbrush or large, stiff brush for spattering

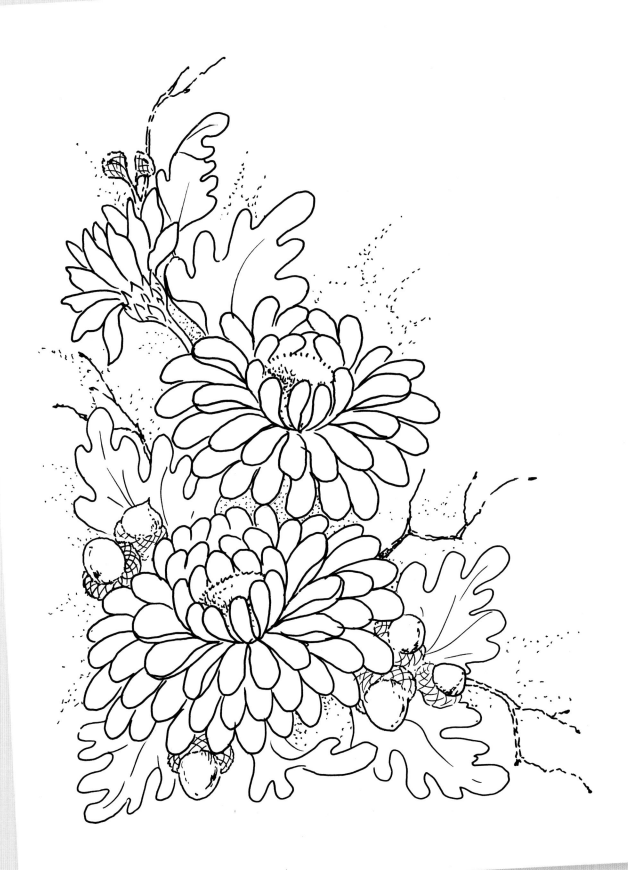

This pattern may be hand-traced or photocopied for personal use only.
Enlarge at 111% on a photocopier to bring it up to full size.

Before you paint. Prepare the background texture as described on page 23. Once the surface has been properly prepared and dried, trace and transfer the pattern.

1. Outline the main elements. Using a no. 4 liner, outline the butterfly, leaves, branches and acorns with thinned Honey Brown. Outline the yellow mum with Cadmium Yellow + Honey Brown, and outline the purple mum with Napa Red.

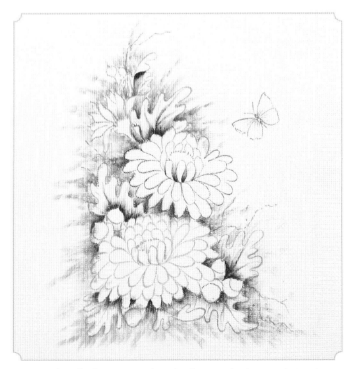

3. Strengthen shadows. Strengthen the deepest shadows and triangle-shaped areas by floating Burnt Umber with a no. 10 flat. Avoid adding too much dark color.

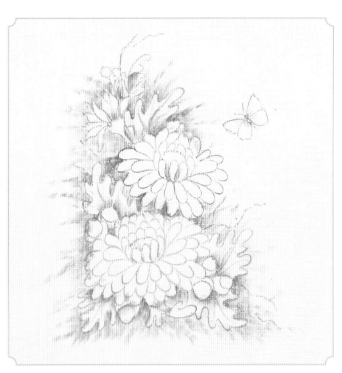

2. Develop shadows. Use a no. 10 flat side loaded with Honey Brown to pat on the background texture and to float the shading on the leaves and mums. Be sure to keep enough medium mix (see page 20) in the brush to ensure the paint sinks easily into the background texture.

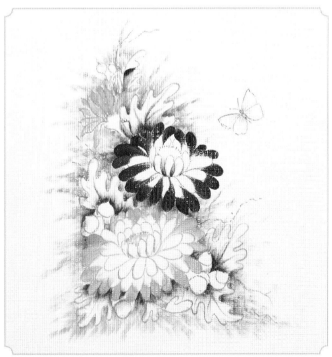

4. Paint the mums. When painting the mums, begin with darker color combinations around the outside perimeter, and transition into lighter values toward the center. Don't worry if the paint skips and allows some of the background color to show through. Use a no. 8 filbert for the largest petals.

For the yellow mum, load the brush with Cadmium Yellow and tip the end with a brush-mix of Cadmium Yellow + Honey Brown. Carry medium mix in your brush so the color is slightly thinned. For the purple mum, place the first layer of petals with Napa Red.

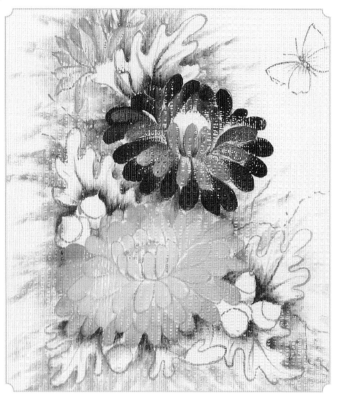

5. Paint the mums. Continue using the no. 8 filbert. The remaining yellow petals are brush-mixes of Cadmium Yellow and Warm White that get increasingly lighter toward the center of the flower.

The remaining purple petals are brush-mixes of Napa Red and Warm White that get increasingly lighter toward the center of the flower.

6. Detail the petals. Use a no. 1 mid-liner to detail and separate the yellow petals with a brush-mix of Honey Brown + Tangelo Orange. Detail and separate the purple petals with a brush-mix of Napa Red + Dioxazine Purple.

7. Detail the mums' centers. With a no. 6 filbert, tap in the centers of both flowers with Cadmium Yellow, shading with Honey Brown. Detail the centers, the acorns and the branches with a no. 1 mid-liner loaded with Burnt Umber.

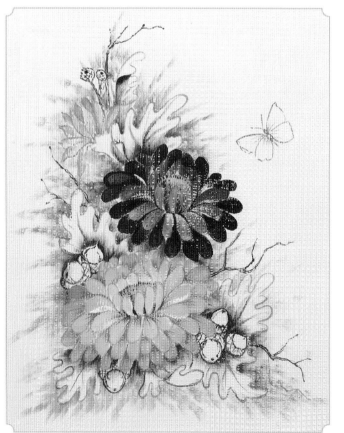

Tip of the Brush

Keeping your work light and airy in the initial stages allows shading and highlight values to give depth and form to the individual flowers, as well as to the bouquet as a whole.

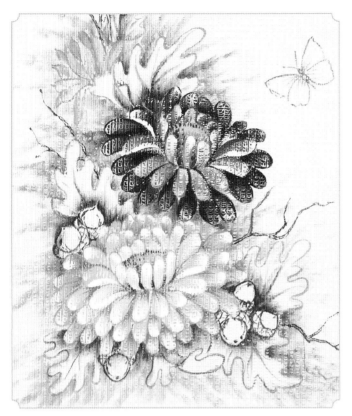

8. *Highlight the mums*. With the no. 8 filbert, add touches of Warm White to the tips of the petals. Stroke the flipped petal edges with a no. 4 liner.

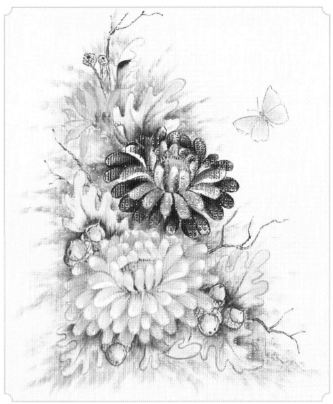

9. *Apply color glazes*. All glaze colors are thinned with medium mix and applied with a no. 8 filbert brush. As you apply the glazes, work some of the color onto the textured background surrounding the design elements. Allow the colors to spray gracefully outward to soften the background.

Apply a glaze of Yellow Light to the butterfly, the leaves, the flower centers and the yellow flower petals. Allow the Light Mocha background color to show through in the highlights.

10. *Apply a yellow-green glaze*. Create a yellow-green glaze by mixing Yellow Light + Evergreen. Place the mixture near the center of the leaves and on the acorns and dab into the background.

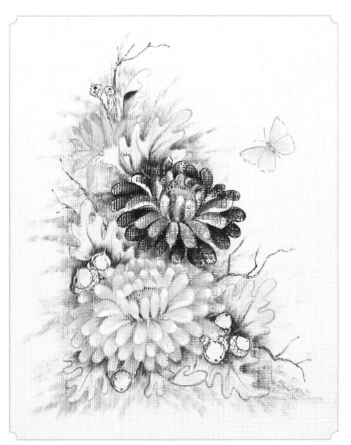

Tip of the Brush

For "floated color," select a flat brush that is slightly larger than the area to be colored. Use clean water and/or extender medium to help the paint transition gradually from the color-loaded edge into the clean edge. Place the entire width of the brush against the surface as you apply the stroke.

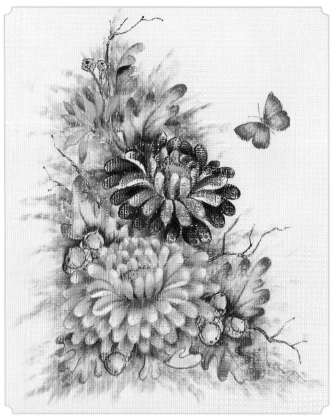

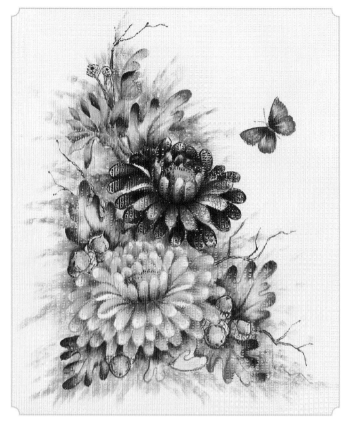

11. Apply an orange glaze. Apply the remaining glaze layers as floated color using side-loaded flat brushes. Tint the butterfly wings and selected leaf tips with Tangelo Orange, allowing the color to fade on the leaves farthest from the center of interest. Shade and separate the yellow flower petals.

12. Apply a red glaze. Float a glaze of Napa Red along the shaded edges of the purple flower. Also shade the mum bud, the butterfly wings at the body and on top of the orange on some random leaf tips.

13. Apply a purple glaze. Float a final glaze of very weak Dioxazine Purple in the deepest shadows behind the flowers and at the base of the leaves. Tap some of the glaze on the background surrounding the design.

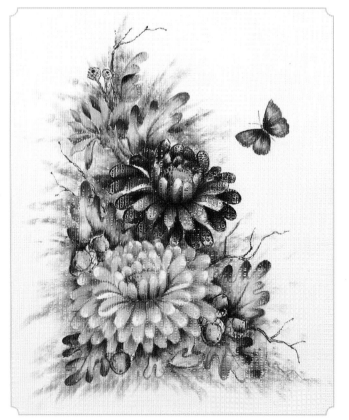

Tip of the Brush

Since colors change as they cure, after the painting has dried, additional color can be added to adjust color intensity.

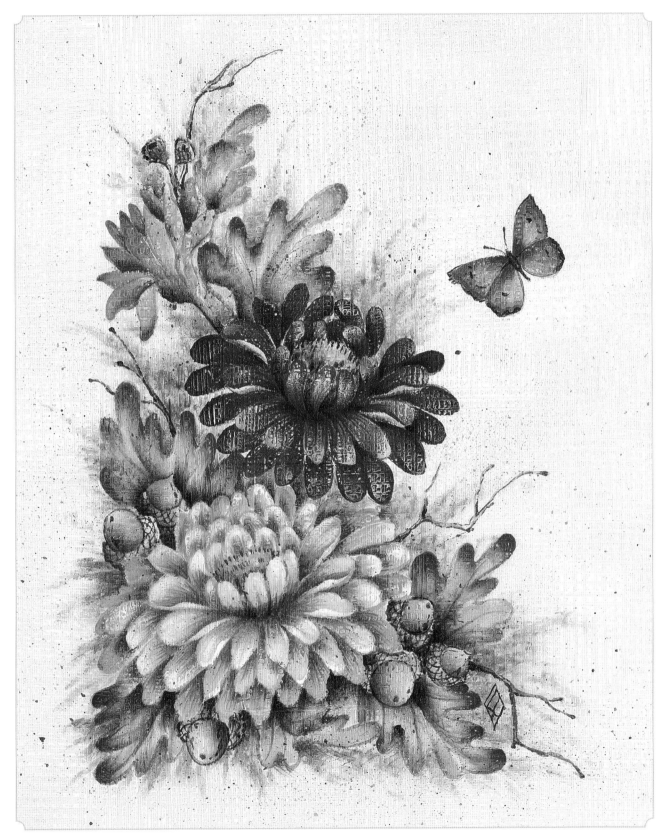

14. Add final details and spatter. Detail the butterfly with a no. 10/0 mid-liner and Burnt Umber. Also shade and detail the branches with the same brush. Cover the large mums with torn paper towels. Alternately spatter Honey Brown, Burnt Umber and a mixture of Burnt Umber + Dioxazine Purple (see page 21).

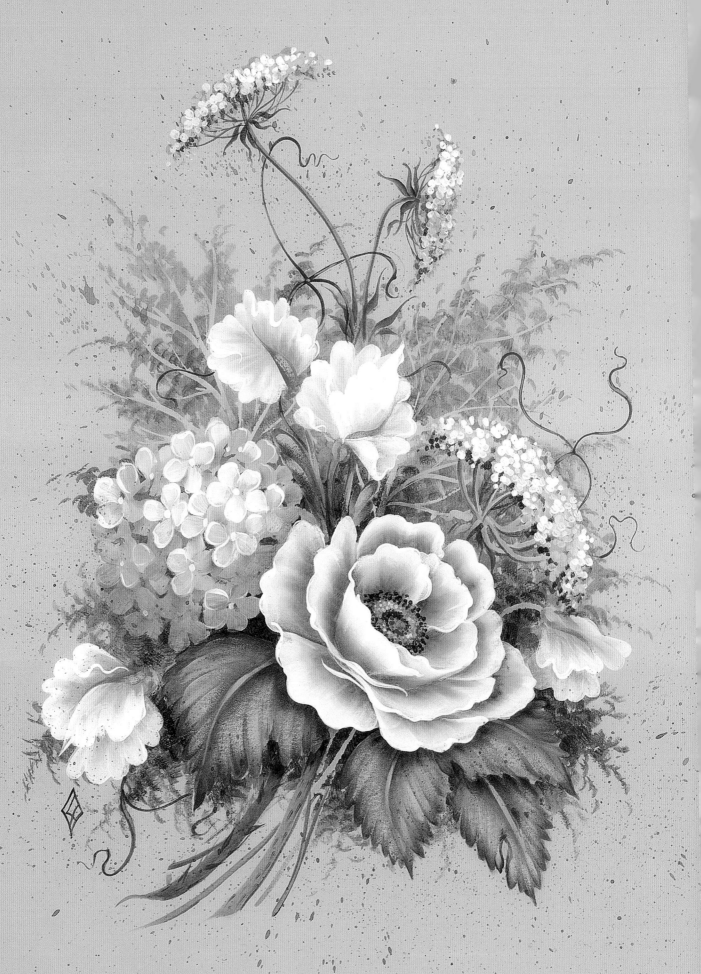

Cottage Garden

The green-on-green of this achromatic color harmony is balanced by the pale pink sweet peas and touches of red on the leaves. Interest is created by using a variety of contrasting color values, temperatures, intensities and textures. The rose element could even be used alone very effectively.

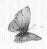

"There my garden grows again Green and rosy painted."
—ROBERT LOUIS STEVENSON

PALETTE: DECOART AMERICANA ACRYLICS

| Snow (Titanium) White | Warm White | Cadmium Yellow | Yellow Light | Honey Brown |

| True Red | Olive Green | Forest Green | Evergreen | Payne's Grey |

Burnt Umber

BACKGROUND COLOR

Soft Sage

Materials List

Brushes: no. 3 round; nos. 2, 4, 6, 8 and 10 flats; nos. 4, 6 and 8 filberts; nos. 10/0 and 1 mid-liners; ¼-inch (6mm) and ⅜-inch (10mm) angular bristles

Additional materials: blue masking fluid; old round brush; art eraser; bar of soap; DecoArt Easy Float; DecoArt Faux Glazing Medium; toothbrush or large, stiff brush for spattering

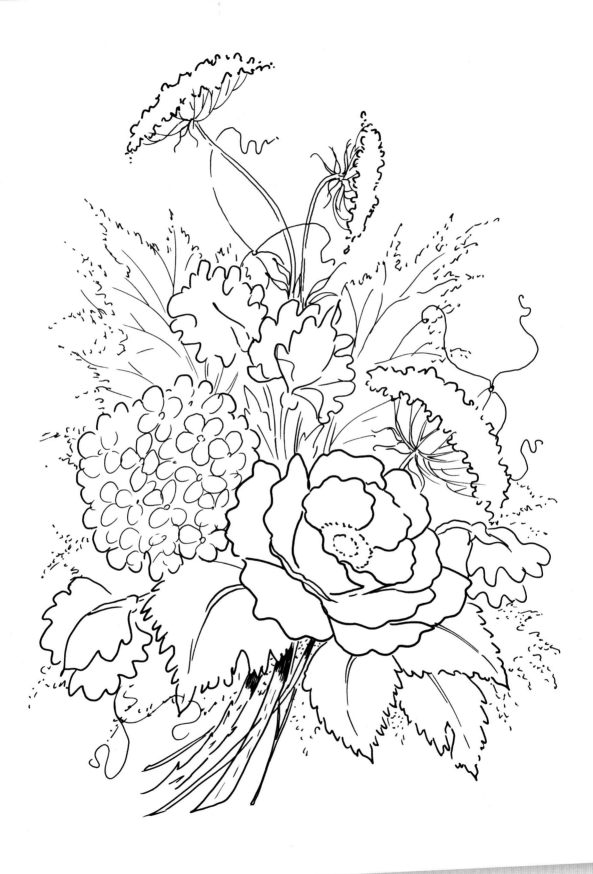

This pattern may be hand-traced or photocopied for personal use only.
Enlarge at 111% on a photocopier to bring it up to full size.

Before you paint. Basecoat your surface with Soft Sage. Trace and transfer the pattern.

1. Apply masking fluid. See the instructions on page 20 to mask the main flowers, leaves and stems with blue masking fluid. Develop petal shapes and textures with the masking fluid on the hydrangea and Queen Anne's lace and leave open spaces within these flowers. It is not necessary to fill in the rose or large leaves with masking fluid. Simply cover the borders well to protect the edges.

2. Develop the background. Use a no. 6 filbert dressed in medium mix (see page 20) and loaded with a brush-mix of Olive Green + Evergreen to pat in the green background between the flowers. Spray outward from the design elements to create a fern-like effect. Be sure the large Queen Anne's lace and hydrangea are covered with the green mixture. Pick up more Evergreen toward the center to create a gradual transition from light to dark. The areas of deepest shadow (behind the rose and large leaves) are tapped with a mixture of Evergreen + Payne's Grey. Use Olive Green to stipple the two Queen Anne's lace at the top of the design that are not covered with mask. Let dry.

Lift the edges of the masking fluid gently with an art eraser and carefully pull the mask from the surface. Dust away particles with a clean, dry paper towel (see page 20).

3. Basecoat the leaves and add the stems. Base the large leaves and main stems with Olive Green using a no. 6 filbert dressed with medium mix (see page 20). Do not paint the negative-space stems formerly protected by the masking fluid.

Using a no. 1 mid-liner double loaded with Olive Green and Forest Green, place the main and secondary stems of the two top Queen Anne's lace. Add Evergreen to the brush and stroke the small calyx leaves.

The dark sweet pea vines are Evergreen. The remaining dark stems throughout the foliage and the veins on the large leaves are a mixture of Forest Green + Evergreen placed with the no. 1 mid-liner.

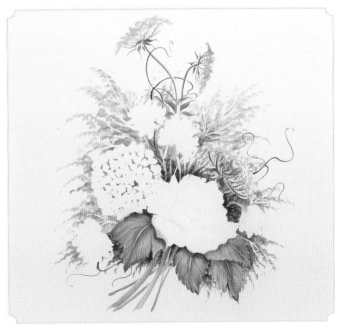

4. Shade the leaves. Shade the leaves by floating Evergreen on a corner-loaded flat brush. Choose appropriately sized flats based on the size of the area being shaded. Floated color pushes back all of the stems behind the flowers, particularly the rose. Let the shading dry. Tint the edges of the larger leaves by floating Honey Brown with a no. 10 flat. Also touch some of the Honey Brown along the fern stems.

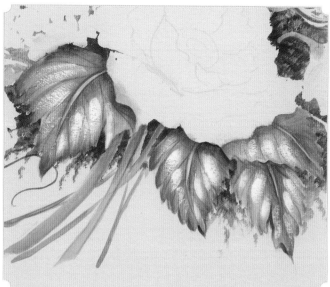

6

6. Shade the Queen Anne's lace. Dab the shaded areas of the Queen Anne's lace petals with Evergreen loaded on the point of a no. 3 round. These dots create patterns of negative space on the shaded side of the flower.

7

5. Highlight the leaves. Drybrush the highlights on the leaves with a no. 4 filbert using Warm White.

7. Add florets to the Queen Anne's lace. Place tiny floret petals with Warm White using the point of the no. 3 round. Remember to allow the green underpainting to show through. Then add heavy accents of Snow (Titanium) White to areas hit by the light source. Paint the finest stem framework with Forest Green using a no. 10/0 mid-liner.

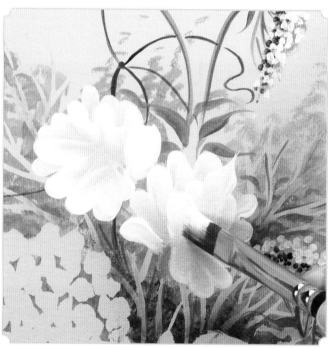

8. Place the sweet pea petals. Execute the sweet pea petals with a no. 8 flat double loaded with Warm White and a pale pink mixture (Warm White + a touch of True Red + a touch of Olive Green). Apply color following the outside edges of the wavy petals, keeping the pink hue toward the center of the flower. Let dry. Float top-lying edges with Warm White.

Tip of the Brush

Your paint may begin to dry out as you work through this lesson. Use fresh paint for the rose, as it will be easier to work with and will flow better.

9. Detail the sweet peas. Outline the ruffled edges and petal flips with Snow (Titanium) White using a no. 10/0 mid-liner. Stroke green calyx leaves with a mixture of Cadmium Yellow + Forest Green and add detail lines with Forest Green.

10. *Develop the hydrangea petals.* Place clusters of florets on the hydrangea using a no. 4 filbert. Begin with thinned Olive Green and gradually pick up Warm White for the top-facing petals. Leave negative spaces between floret petals. Let dry. Strengthen highlighted petals with more Warm White.

11. *Shade the hydrangea petals.* Shade the floret centers and separate individual petals with floated color using a mixture of Forest Green + Evergreen and a no. 4 flat.

Also use this mixture to bring back any negative spaces lost when adding the florets.

12. *Highlight the hydrangea.* Add highlights and details with a no. 10/0 mid-liner loaded with Warm White. Begin on the edges of the top-facing petals. Outline each petal with two strokes and place a single dot of white at the floret center. Make the details less pronounced as the petals move away from the center of the flower.

13. *Place the rose petals.* Establish the individual rose petals with nos. 6 and 10 flats double loaded with Warm White and a mixture of Olive Green + Evergreen + Warm White (1:1:1). The first color placement carefully follows the contour of each petal. Begin with the back petals and work around to the outermost petals along the outside edges.

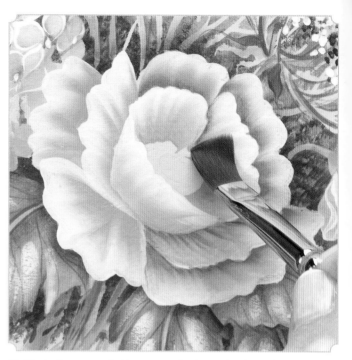

14. *Complete the rose petals.* Continue to establish the individual rose petals, working inward toward the center of the flower.

15. *Shade the rose petals.* Use a no. 10 flat dressed with medium mix to accent the shading with a floated wash (very weak color) of Evergreen + Payne's Grey mixture. Spread this color very thin so it is only a shadow along the back edges of the petals to separate them. (In the photo for this step, the right half of the flower has been shaded while the left side has not: Note the difference in the color values.)

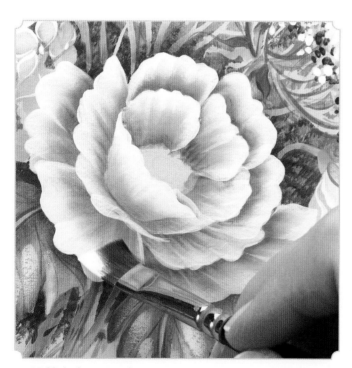

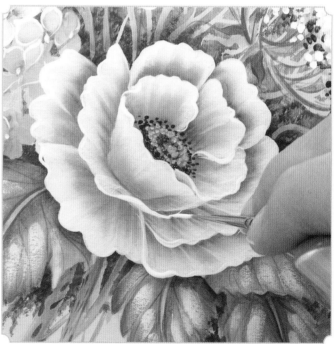

16. *Highlight the rose petals.* Reinforce highlighted petal edges with Warm White side loaded on the long hairs of either a ¼-inch (6mm) or ⅜-inch (10mm) angular shader. On the front center petal, begin the float at the center of the petal and move first to the left and then to the right, with the loaded long hairs of the brush facing the edge of the petal. Be sure all the hairs of the brush are against the painting surface to get a smooth transition of color from the clean edge to the painted edge.

17. *Detail the center of the rose.* Base the center of the rose with dabs of Olive Green loaded on a no. 1 mid-liner. Then add dabs of Cadmium Yellow using the point of the cleaned brush. Shade with Honey Brown followed by Burnt Umber pollen. Highlight the yellow pollen with Warm White. Accent curled and flipped edges and forward-facing petal edges with lines of Snow (Titanium) White using a no. 10/0 mid-liner.

18. Apply glazes of color. Thin each glaze color with medium mix and apply with a no. 8 filbert. Clean the brush between color layers. Create a yellow-green glaze from Yellow Light + a touch of Forest Green and use it to warm the background ferns, the lower edges of the Queen Anne's lace and the highlighted area of the hydrangea. Also warm the center of the rose and the base of the sweet peas. Brush a variation of the yellow-green over the larger leaves and on the major stems.

Mix True Red + a touch of Snow (Titanium) White (and thin with medium mix) to create a very weak tint. This tint kisses a few of the outer rose petals and the Queen Anne's lace to reflect some of the color of the sweet peas. If the sweet peas need a stronger color, touch them very lightly with the tint. Also float tints on the tips of the major leaves using a no. 8 flat. Be careful not to overpower the painting with pink.

Finally make a very weak mixture of Payne's Grey + a touch of Evergreen and use it to separate the hydrangea from the rose. Also use this mixture anywhere cast shadows need to be strengthened in the greens.

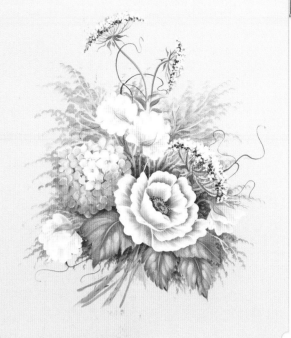

19. Spatter. Cover the central area of the arrangement with pieces of torn paper towel. Spatter the exposed areas with Honey Brown and assorted green mixtures from the palette. Continually turn the composition so the spatter flecks outward from the design radius (see page 21).

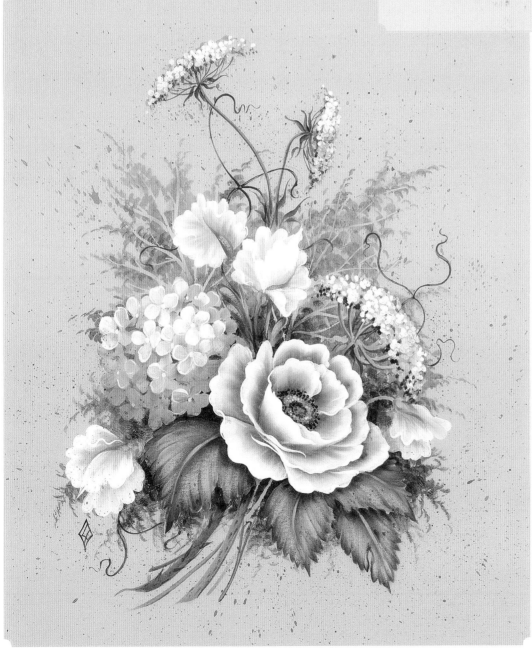

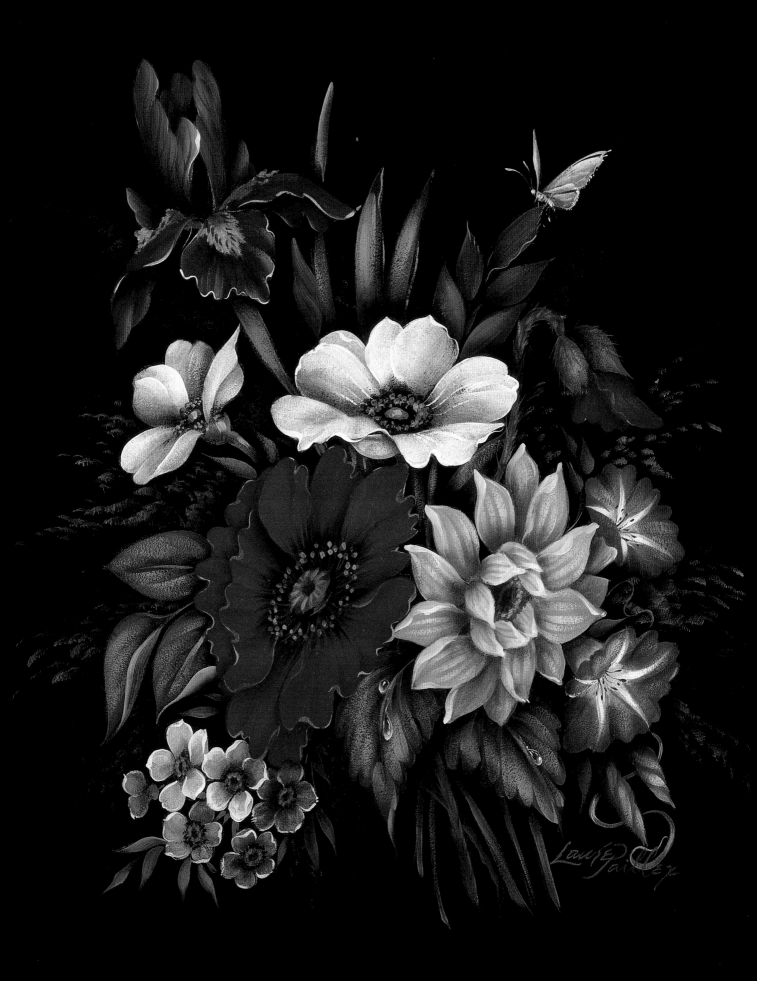

Elegance in Black

A rich, velvety black background provides high contrast for this bright floral composition resulting in a very dramatic effect. By comparing this painting with the Rainbow Mix bouquet (page 72), we can see how our choice of background color affects the look of our final painting. Painters in the classic tradition most often use a dark, neutral background for their floral still-life compositions.

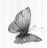

"The glory of the garden it abideth not in words."

—RUDYARD KIPLING

PALETTE: DECOART AMERICANA ACRYLICS

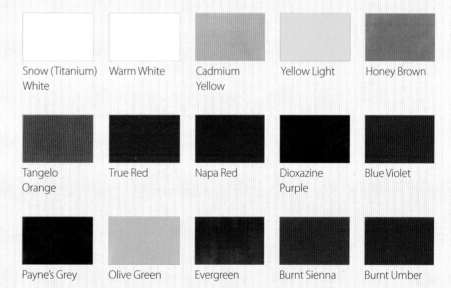

Snow (Titanium) White	Warm White	Cadmium Yellow	Yellow Light	Honey Brown
Tangelo Orange	True Red	Napa Red	Dioxazine Purple	Blue Violet
Payne's Grey	Olive Green	Evergreen	Burnt Sienna	Burnt Umber

BACKGROUND COLOR

Lamp (Ebony) Black

Payne's Grey

Materials List

Brushes: no. 3 round; nos. 8 and 10 flats; no. 4 liner; nos. 2–10 filberts; nos. 10/0 and 1 mid-liners

Additional materials: DecoArt Easy Float; DecoArt Faux Glazing Medium

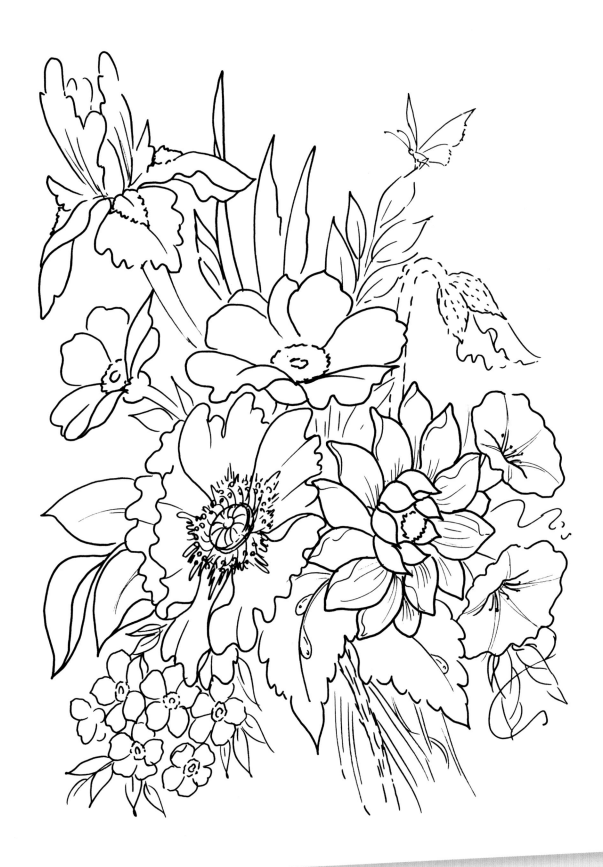

This pattern may be hand-traced or photocopied for personal use only.
Enlarge at 111% on a photocopier to bring it up to full size.

Before you paint. Basecoat your surface with Lamp (Ebony) Black. Let dry. Add a top coat with Payne's Grey to unify the background with the final Payne's Grey shading on the flowers and leaves. Let dry. Trace and transfer the pattern with light or white transfer paper.

1. Underpaint forms in white. Using various sizes of filberts ranging from nos. 2 to 10, underpaint the main flowers and leaves with Warm White using unfinished strokes that allow the black background to show through in the shaded areas. Add a touch of Burnt Umber to the Warm White for the small phlox petals at the bottom left. Let everything dry and remove the transfer lines.

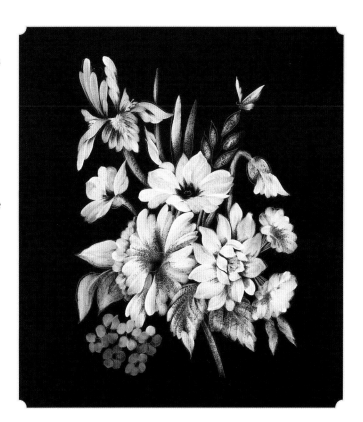

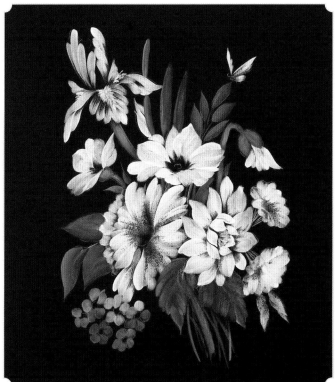

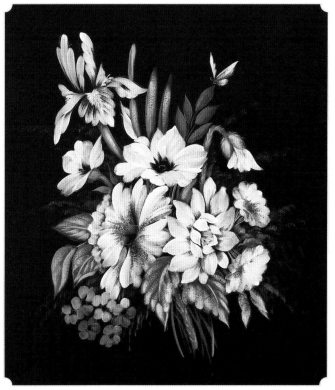

2. Paint the stems and leaves. Using various sizes of filberts, lay in color on the stems and green leaves with Evergreen, side loading the brush with Olive Green on highlighted areas. Paint the small leaves under the butterfly and some of the stems at the bottom with a no. 8 filbert double loaded with Honey Brown and Burnt Sienna.

3. Highlight leaves. Double load a filbert with Evergreen and Olive Green and tap on some airy background ferns extending out from the main bouquet in a few places. Use a brush-mix of Warm White + a touch of Olive Green to drybrush highlights and details onto the leaves.

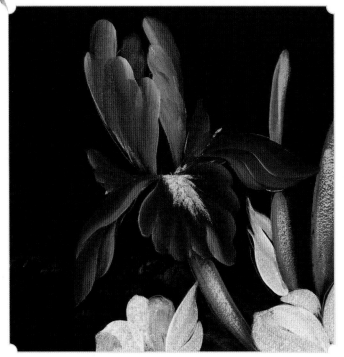

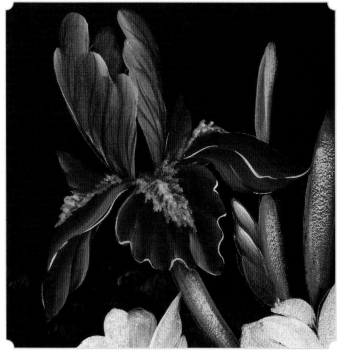

4. Paint the iris petals. The upright standing petals are initially stroked with Dioxazine Purple using a no. 8 filbert. Separate and highlight the individual petals by working Warm White into one edge of the purple-loaded brush.

The lower three petals are placed with a brush-mix of Napa Red + Blue Violet. Define and highlight these petals by working Warm White into the edge of the violet-loaded brush.

Drybrush Warm White on the center petal as an undercoat for the "beard."

5. Detail the iris. Double load a small filbert with Cadmium Yellow and Honey Brown and stipple in the beards on the falls. Shade and detail with Burnt Sienna. A slightly worn brush will produce the best texture.

Pull veins in the petals of the purple standards with thinned Dioxazine Purple using a no. 1 mid-liner. Outline the three falls with a no. 10/0 mid-liner loaded with Warm White tinted with a tiny touch of Napa Red. Using a no. 4 filbert, paint the tight iris bud with strokes of Dioxazine Purple tipped with a little Warm White.

6. Add color to the morning glories. Lay in the color on the open morning glories and the closed buds with medium-value blues using brush-mixes of Blue Violet + Warm White on a no. 6 filbert.

7. Add ribs to the morning glories. Drybrush up the trumpet with Warm White on a no. 4 liner, and then pull three white rib strokes from the base of the trumpet outward to the edge on the open morning glories.

Tip of the Brush

Work around the painting so adjoining areas have time to dry before applying the next strokes of white. This prevents lifting off that nice, heavy ridge of white that you put down first.

8. Complete the morning glory petals. Switch to a no. 4 filbert to define the petals on the front edge of the ruffle with a darker value of the blue-white mixture from step 6. Lightly blend the strokes to unify the colors.

9. Complete the morning glories. Using a no. 8 flat, float Warm White in the throat of the trumpet and under the front petal edge to define and separate the trumpet from the blue corona. Add the last two white ribs on the front petals with short, curving strokes following the contour of the petal.

Load a no. 10/0 mid-liner with Burnt Sienna and add the fine stamen filaments emerging from the throats; press a little dot at the end of each stamen. Unify the outside edges of the open petals with a float of Blue Violet and shade the bud bases where they tuck behind the open blossoms.

10. Glaze the anemones. On the white anemones, float a weak glaze of Burnt Umber + medium mix (see page 20) along the shaded edges of the petals using a no. 10 filbert. Dress the filbert with clean medium mix and side load with a heavy edge of Snow (Titanium) White. Stroke the high-lighted edge of each petal, walking this color across the petal to blend with the shaded edge. Paint the phlox in the lower left-hand side of the bouquet with the same color sequence as the anemones in step 11.

11. Detail the anemones. Tap in the anemones' centers with a mixture of Lamp (Ebony) Black + Payne's Grey on a no. 3 round. Dot in the pollen rings with Cadmium Yellow. Layer the center pollen dots with Cadmium Yellow and Tangelo Orange. Tap in the centers of the phlox with the same colors and brush used for the anemone centers. Use a no. 10/0 mid-liner with Snow (Titanium) White to loosely outline the edges, flips and turns on the anemone and phlox petals.

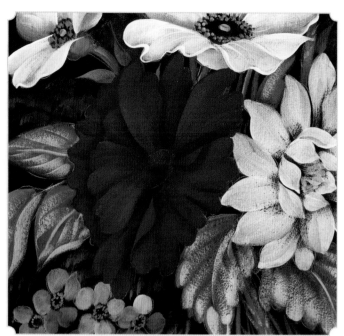

12. Develop the Oriental poppy's petals. Double load Tangelo Orange and True Red on a no. 8 filbert. Lay in the first coat of color on the open poppy petals and the closed bud to the right of the anemones. Follow the direction of the underlying white basecoat strokes, blending the strokes to unify each individual petal.

Apply a second coat if needed; however, allowing the black background to show through in the shadow areas means you have already established some of the shading.

13. Apply shading to help separate the petals. The first shading is floated with a mixture of Napa Red + a touch of Lamp (Ebony) Black on a no. 8 flat. This shading helps separate the petals and pulls some of them forward while setting others back. It also helps establish the folds and ruffles in the contours of the petals. Don't forget to shade the bud at the same time.

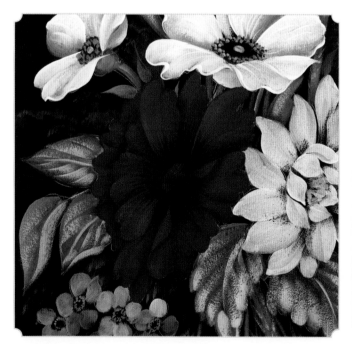

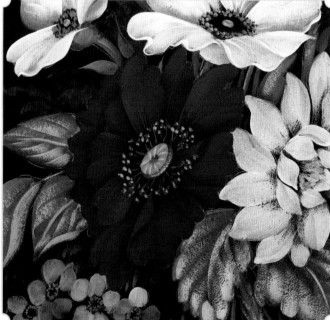

14. Detail the poppy petals. With a no. 4 liner, brush-mix Lamp (Ebony) Black + a touch of True Red and outline the center seedpod with a circular line; then pull fine detail lines out from that circular line. The color is applied slightly dry so the lines have a velvety texture.

15. Complete the poppy's center. Place the center button with Olive Green shaded with Evergreen using a no. 3 round. Load a no. 10/0 mid-liner with Cadmium Yellow and press short lines radiating outward on the center button. Pull fine filaments for the stamens with Burnt Sienna + Honey Brown on the no. 10/0 mid-liner. Start the pollen dots with the same mixture, and then add Cadmium Yellow, Tangelo Orange and Burnt Sienna dots as needed for contrast.

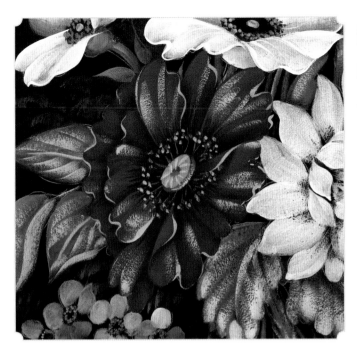

16. *Highlight the poppy.* Drybrush highlights with Warm White + a touch of Tangelo Orange using a no. 4 filbert. (These are placed on the raised folds and the top-lying edges of the poppy petals.) Load a no. 10/0 mid-liner with the same color mixture and outline the edges of the petals.

17. *Develop the dahlia petals.* Lay in the color on the underlying petals with a mixture of Cadmium Yellow + Honey Brown on a no. 6 filbert. Reload the brush and adjust the color with a little Warm White for each petal, depending on which edges are lying on top. Switch to a no. 4 filbert and use the same colors for the smaller standing petals in the center, but this time pick up more Warm White in your brush to lighten the top-lying edges to separate these petals from the ones beneath them.

18. *Shade the dahlia petals.* Shade and separate the dahlia petals with floats of Honey Brown followed by smaller floats of Burnt Sienna in the deepest shadows using a no. 8 flat dressed with medium mix.

19. *Complete the dahlia details.* Use the point of a no. 4 liner to tap in the center with Burnt Sienna. Add pollen dots with Cadmium Yellow, Honey Brown and Tangelo Orange. Tap a little Lamp (Ebony) Black into the deepest shadows of the center. Use a no. 3 round to drybrush Warm White highlight streaks on each of the petals, starting at the base and extending out to the tip, following the contour of each petal. Switch to a no. 10/0 mid-liner and detail the tips and edges of each petal with long, fine comma strokes that follow the edge contours.

20. Apply warm color glazes. Use medium mix to thin each color, altering the ratio of paint to medium to adjust the color transparency. Apply glazes with a side-loaded no. 10 filbert. Apply Yellow Light to the dahlia petals, the yellow pollen in the flower centers, the iris beard, the throat on each morning glory and the butterfly. Brush Yellow Light + a touch of Evergreen over the leaves and stems and the calyx of the Oriental poppy bud, and here and there near the centers of the phlox. Use a very weak yellow-green to tint around the centers of the white anemones.

Brush a glaze of True Red + Tangelo Orange over the red Oriental poppy; pick up more orange for the high parts of the petals and more red for the lower petals and the shadowed areas.

Using a side-loaded flat, kiss the serrated edges of the leaves and the shaded areas of the dahlia with a glaze of Tangelo Orange. Remember to glaze the phlox, the brown leaves and the butterfly.

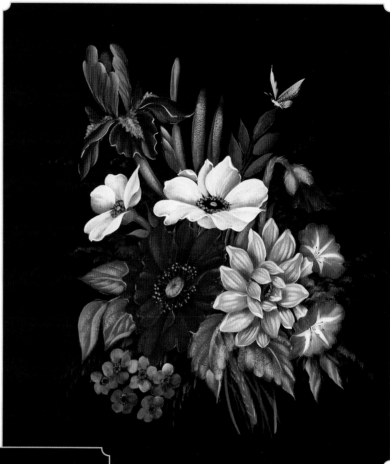

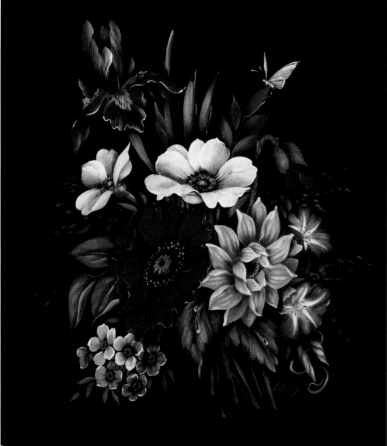

21. Apply cool color glazes. Lay on cool glazes using a side-loaded no. 10 flat. Float Napa Red tints on the butterfly, at the base of the iris beards and on random leaf tips. Touch a hint of color on the shaded areas of the white anemones.

Mix Dioxazine Purple + Payne's Grey with medium mix to create a purple-gray glaze, and shade the base of the iris petals and the trumpets and ruffles on the morning glories.

Use a Payne's Grey glaze to push back leaves and stems wherever they recede under other elements. Separate individual anemone petals and shade any other objects that need to recede into the background with a very weak wash of Payne's Grey.

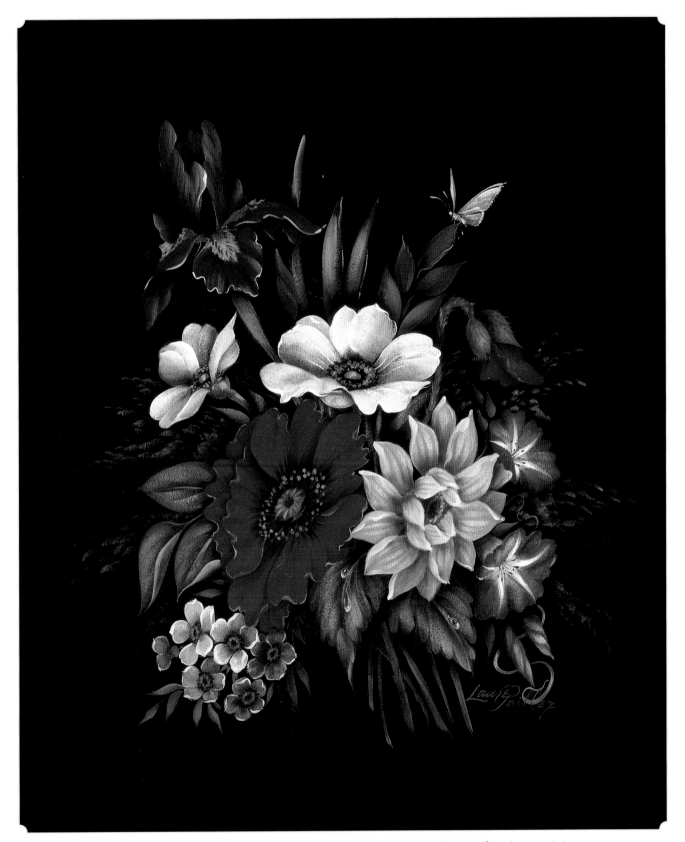

22. Add details and water droplets. Add more subtle filler leaves if needed to enhance the overall shape of the design with the same brush and colors used in steps 2 and 3.

Outline the water droplets on the large leaves with Snow (Titanium) White on a no. 10/0 mid-liner. Float a dark value of the background leaf color along the top edge and below the bottom edge of the droplet. Float a thin, white highlight on the droplet along the bottom edge. There should be a sharp contrast between highlight and shadow along the bottom edge of the droplet. Add tiny white sparkle dots near the center of the drop reflecting the light sources in the composition.

The pieces featured on these pages illustrate a few of the ways the bouquets in this book can be applied to three-dimensional decorative surfaces. Your paintings can also be rendered on artist's canvas for traditional framing. The steps outlined in Part One will help you adapt the arrangements to a variety of unique surface shapes and sizes.

I sincerely hope you'll continue exploring the joys of painting fresh and fabulous flowers in acrylics.

Heart Basket

Mini Tin Pocket

Tree Basket

Coaster Box

Mini Tin Pocket – This square shape is divided diagonally by the brushes, and the lines are softened by the casual placement of flowers and grasses.

Heart Basket – The *Cottage Garden* bouquet rests gracefully within the curves of this heart-shaped lid. Design elements can be added or subtracted to suit the size and scale of your surface.

Tree Basket – Because the evergreen tree suggests a triangle shape, the *Noel* bouquet both suits the format and carries the winter theme.

Coaster Box – *Merry and Bright* fits perfectly on this coaster box. Several of the small, simple composition bouquets could be used effectively on a small round surface.

Scrapbook Cover – An "L"-shaped composition often works well in a rectangular space, especially if room is needed for other elements such as lettering, cutouts or photos.

Fashion Purse – The modern trapezoid shape and the bamboo handle on this little wooden purse cried out for a simple yet elegant design. *Exotique,* rendered on a woven-textured background, is a perfect match.

Scrapbook Cover

Fashion Purse

These patterns may be hand-traced or photo-copied for personal use only.

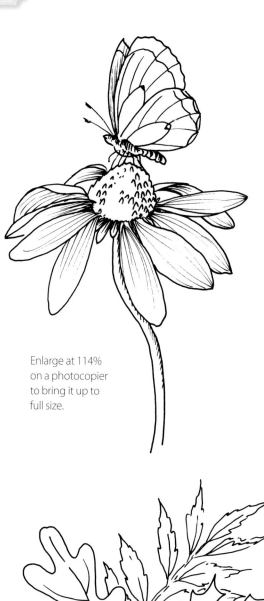

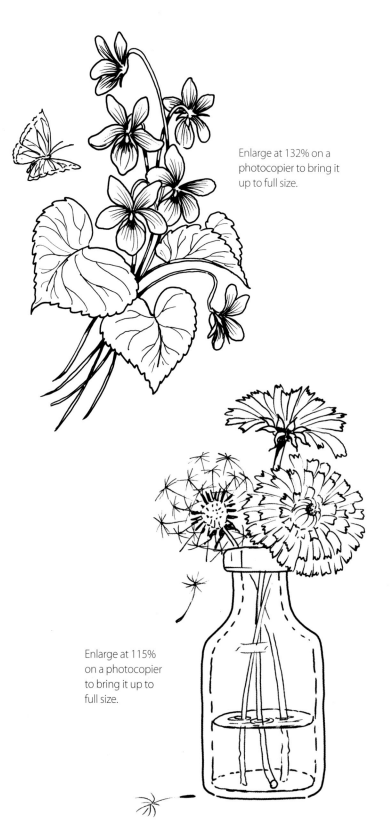

Enlarge at 132% on a photocopier to bring it up to full size.

Enlarge at 114% on a photocopier to bring it up to full size.

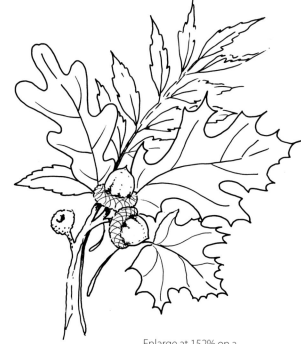

Enlarge at 115% on a photocopier to bring it up to full size.

Enlarge at 152% on a photocopier to bring it up to full size.

Enlarge at 122% on a
photocopier to bring it
up to full size.

Reduce at 98%
on a photocopier
to match the
original design.

Enlarge at 125% on a
photocopier to bring
it up to full size.

These patterns may be hand-traced or photo-copied for personal use only.

Enlarge at 128% on a photocopier to bring it up to full size.

Enlarge at 154% on a photocopier to bring it up to full size.

Enlarge at 135% on a photocopier to bring it up to full size.

The best in art instruction and inspiration is from
NORTH LIGHT BOOKS!

Fast & Fun Flowers in Acrylics

Popular artist Lauré Paillex shows you everything you need to create fun, bright and colorful flowers of all kinds! You'll find more than 60 step-by-step demonstrations that give you great results in a jiffy. No demo is more than six steps long, and the convenient lay-flat spiral binding makes this a book you'll keep open on your painting table for quick reference anytime. From garden flowers to wildflowers and spring bulbs to roses and orchids, you'll find just the flower you need for any project—or just for the fun of painting.
ISBN-13: 978-1-58180-827-8, ISBN-10: 1-58180-827-5, hardcover, 128 pages, #33503

Painting Fabulous Flowers with Donna Dewberry

Donna Dewberry shares her latest innovations in one-stroke painting, featuring fifty all-new flowers and ten fresh floral compositions you can apply to virtually any project. This inviting reference covers a range of blooms, and comprehensive step-by-step acrylic painting demos accompany each flower so you can pick up Donna's trademark techniques with ease.
ISBN-13: 978-1-58180-857-5, ISBN-10: 1-58180-857-7, paperback, 160 pages, #Z0168

Creating Textured Landscapes with Pen, Ink and Watercolor

Bring your watercolor landscapes to life with the rich texture of pen and ink. With the help of reference photos and field sketches, bestselling author Claudia Nice teaches you how to create realistic and colorful landscapes ranging from expansive mountain vistas to more intimate vignettes such as tree-shaded streams. Each chapter explores a different component of landscape painting: skies and clouds, hills and mountains, trees and foliage, rivers, lakes and waterfalls, rocks, flowers and more.
ISBN-13: 978-1-58180-927-5, ISBN-10: 1-58180-927-1, hardcover, 144 pages, #Z0568

Cute Country Animals You Can Paint

Ten complete step-by-step demonstrations show you how to paint adorable country animals, including little lambs, precocious piglets, playful pups, cuddly kittens and their loving, watchful mothers. Eighteen minidemos help you capture the details of the animals' surroundings, from peaceful farmyards and pastures to mountain meadows and flower-filled paths. All projects are painted with acrylics, and the detailed instructions are easy for painters of any experience level to follow.
ISBN-13: 978-1-58180-975-6, ISBN-10: 1-58180-975-1, paperback, 128 pages, #Z0785

These books and other fine North Light titles are available at your local arts & crafts retailer, bookstore or from online suppliers.